THE MISSISSIPPI PHOTOGRAPHS OF HENRY CLAY ANDERSON

With Essays by Shawn Wilson, Clifton L. Taulbert, and Mary Panzer

PublicAffairs NEW YORK

SEPARATE, BUT EQUAL

Copyright © 2002 by Anderson LLC.

Published in the United States by PublicAffairs™, a member of the Perseus Books Group.

All rights reserved.

Printed in Italy by Amilcare Pizzi, s.p.a.

Book design and composition by Mark McGarry, Texas Type & Book Works.
Set in Scala with Corvinus display.

Library of Congress Cataloging-in-Publication Data

Anderson, H. C. (Henry Clay), 1911–1998.

Separate, but equal: the Mississippi photographs of H. C. Anderson /

Shawn Wilson, Clifton L. Taulbert, Mary Panzer. — 1st ed.

p. cm. ISBN 1–58648–092–8

1. African Americans — Segregation — Mississippi — Greenville — Pictorial works.

2. Greenville (Miss.) — Race relations — Pictorial works.

3. Documentary photography — Mississippi — Greenville.

I. Wilson, Shawn. II. Title.

F349.G8 A85 2002 305.896'073076242 — dc21

2002021973

FIRST EDITION

10 9 8 7 6 5 4 3 2 1

This book is dedicated by Shawn Wilson

to his mother, Myra Wilson, 1945–1984

CONTENTS

Throughout his career, H. C. Anderson favored the same professional equipment that could be found in pressrooms and portrait studios around the country. His cameras produced large negatives, on rectangular sheets of film, 5 x 4 inches. Anderson rarely printed the full negative. Instead, he selected the most important figure, or figures, and eliminated extraneous details that often appear around the edges. (For example, he would never have produced a wedding picture that included a guest holding a fan, though she appeared in the original negative.) In this book, we have printed Anderson's complete negatives. In most cases, we do not know exactly how he would have cropped these pictures. We also found that the full photograph included important historical information. The very living room furniture, parked cars, and children's toys that Anderson would have cropped out give us a rare glimpse into the world in which the photographer and his subjects lived.

Anderson's camera

While many of Anderson's negatives were carefully stored, others were not. We discovered many negatives that had been damaged by water, dirt, and heat, leaving them ripped, curled, scratched, or corroded. But when carefully washed and cleaned, the subjects were still visible, and we have included some of these images, judging that the damage was part of their story.

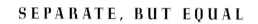

SEPARATE, BUT EQUAL

MEETING MR. ANDERSON

Shawn Wilson

In my wallet there's a tattered black-and-white photograph of my mother. With her big beautiful smile, head tilted to the side, staring into space, she looks like a movie star. My mother always hated snapshots. If she saw someone with a camera she'd say, "Oh don't take my picture!" But she trusted Mr. Anderson. He prided himself on making everyone look their best.

When I was very small, I went with my mother to Mr. Anderson's studio. I remember not liking the way he primped and posed her. My mother had a green thumb. She was always working in the yard, wearing cut-off jeans and my father's old shirt knotted in the front, tending her roses, marigolds, gladiolas, morning glories. On Saturday mornings, she and I pulled the weeds from my small watermelon patch. I preferred my mom as she really was, in the middle of her garden, to this glamorous woman in a dark sweater and makeup. But it is the only photograph of my mother that remains, and she liked it, and she liked Mr. Anderson.

I live in New York, and my sister still lives in Greenville. One day in 1998, talking on the telephone, I asked her about Mr. Anderson. She said he was old and very frail, still living in

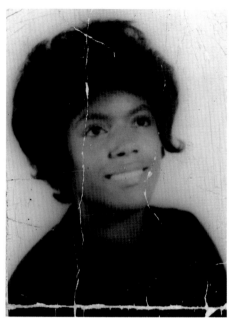

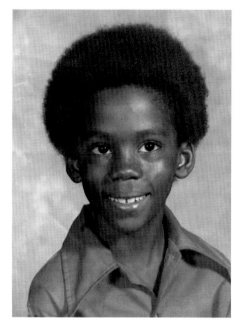

Myra Wilson, aged twenty-four

Shawn, aged five

the same small house off Nelson Street. Right after I hung up, I decided to call him. The operator said the directory showed a Mr. H. C. Anderson on Edison Street in Greenville, Mississippi. I said, "That's him."

His voice was soft when he answered the phone. "Are you Mr. Anderson the photographer?" I asked. "Yes sir," he answered. I introduced myself, and told him he had taken the only remaining photograph of my mother. I asked him if he kept the negatives of his portraits, as I hoped to find more pictures of her, or replace the one I had. "When you are in the business of making portraits for forty years [Mr. Anderson always referred to his photographs as 'pictures' and 'portraits'] and you retire, you don't keep a lot of that stuff. I guess I did keep some things." Somehow I figured that if Mr. Anderson made one photograph that was important to me, he must have made others, for many other people, and I had to convince him to show me the rest of his work. Mr. Anderson hesitated. He told me about a college student who had interviewed him years before, written a paper, and never come back. But at last he agreed that I could come and visit. At the end of our conversation he stopped me and said, "I just have to ask, sir, are you black or white?" When I told him I was black,

I heard a faint chuckle. To his ears, I had lost my southern accent. I felt proud as I answered him — proud of being black — but I was also shocked to realize I took his question as a compliment.

A few weeks later I was on a plane heading for Greenville. It was the first time I had returned home since my mother's death over ten years before. As I pulled up to Mr. Anderson's house, the memories of my first visit to his studio in 1970 came flooding back. I was five years old, and had not yet started school. All the older kids in the neighborhood were having their school portraits taken, and I felt like I was missing the action, so my mother promised to take me to Mr. Anderson to have my portrait taken, too. For the special event, I wore a new lime-green turtleneck sweater with an attached bright yellow vest. My mother had taken me to see Mayrella, the local barber for a "shape-up." Mayrella had carefully picked out my afro (at the time we called it "a natural") so that not a hair was out of place. I was both excited and nervous about my first professional portrait. I remember Mr. Anderson was very serious and yet very gentle when he posed me. He arranged my hands, moved one shoulder forward, and touched my face, then went behind the camera and crouched under the cloth. He stepped back to make adjustments, and returned to the camera again. It seemed like hours before he was satisfied, but his attention made me feel special. Most of all, I remember the way he arranged my hands, one on top of the other. I felt like a little prince. I was very happy that day. These memories now felt like a dream. I was standing before a locked door. Behind it was something I needed, and Mr. Anderson held the key.

Mr. Anderson was much taller than I remembered, but he still had the same head full of white hair. As he invited me in, I saw that his studio had fallen into disrepair. Sitting on his desk was an old cardboard filing box, from which he pulled dozens of crumpled paper envelopes, all containing negatives, and all carefully hand-labeled with the names of the sitters. He also brought out two boxes of photographs. As he reached inside I expected to see more portraits, but instead I saw a foreign town, full of life. It looked like Mayberry, but with an all-black cast. The first photograph was a smiling cheerleader with a megaphone wearing a long dark fifties-style skirt. In the next, lots of pretty young women rode in a parade of shiny convertibles, a homecoming queen surrounded by her court. "Is this Greenville?" I asked. "Yes, this is Greenville."

As we looked at the photographs, Mr. Anderson started to tell me about his town, all the businesses on Nelson Street, Coleman High School, the Doctors' Association, the Women's Auxiliary, all the local ministers and their congregations. He showed me a portrait of

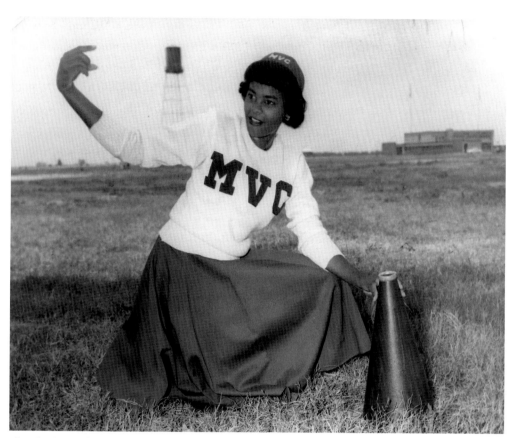

Cheerleader, Mississippi Vocational College

George McKee and his famous Casablanca nightclub, and a surprise birthday party in honor of bluesman B. B. King. He talked about Fanny Lou Hamer and the Freedom Democrats. Mr. Anderson told me that he was the first local Negro to run for city council. Even though he didn't win, he was very proud of the campaign.

I was mesmerized. And I knew this history should be shared. Mr. Anderson had no immediate family; his wife had died and they had no children. He agreed to sell me his old camera and remaining negatives, on the condition that I promise to share his work with the outside world. I left Mr. Anderson's house with a sense of awe. I was grateful that he trusted me with his most precious possession — his life's work. And it had all happened so quickly.

Riding out of Greenville on a Greyhound bus, headed to the airport in Jackson, Mississippi, I began to comprehend the responsibility that I had taken on. I felt that Mr. Anderson had passed the baton to me, and now I was beginning my leg of the relay.

Back in my apartment in New York City, I began going through the hundreds of negatives and original prints Mr. Anderson had made over his long career. As I took each negative out of its envelope, and held it up to the light, I felt like a doctor viewing an x-ray. I was amazed at the things I saw, and impressed by Mr. Anderson's ability to make the town come alive. I saw the Rabbit Foot Minstrels, the black traveling vaudeville show, posing in front of their trailer painted with the sign, The Greatest Colored Show on Earth, and I saw their star, Diamond Tooth Mary. I saw a beauty-school fashion show, the graduates parading their latest hair creations in front of a curtain that read, We need your head to get a head start. An envelope labeled Belzoni, Mississippi, held a gruesome image, a man with a bloated face, lying in his coffin. Later, I learned he was Reverend George Lee, a businessman and early Civil Rights activist. He had been assassinated for joining the NAACP and encouraging his friends and neighbors to register and vote.

One thing disappointed me. Among all those faces I still did not find any evidence of my mother's portrait session with Mr. Anderson. However, I felt a thrill when I saw an envelope bearing the name of Dr. Noble Frisby. According to my birth certificate, I was born at the Frisby Clinic, and Noble Frisby was my mother's doctor. Here was the face of the man who helped usher me into this life. On a small scale, I felt like Alex Haley, finding my roots.

The photographs sparked my curiosity. I wanted to know more about these people, these survivors of segregation. I wanted to give these faces a voice. It was then that I decided to make a documentary film about Greenville. My friend and neighbor, Sean Souza, is a photographer and filmmaker. He had been touched by the photographs, and agreed to help me.

We rented equipment and returned to Greenville. First, we contacted Mr. Roy Huddleston, head of the Nelson Street Revitalization Committee, my former band teacher, and now owner of Bea's Century Funeral Home. The last time I'd been to Bea's Century was for my grandmother's funeral. I was seven, and I still remember my grandma lying in her coffin, wearing a beautiful blue chiffon gown and surrounded by garlands of flowers. In true southern tradition, we had asked Mr. Anderson to come to the funeral home and photograph her in all her final splendor. Everyone received a copy of the photograph.

Mr. Huddleston told us wonderful stories of life in Greenville and helped us arrange interviews with other old-time movers and shakers. Everyone welcomed us. They seemed pleased to share their memories. We concluded our month-long stay by interviewing Mr. Anderson. Though he was growing frailer and his voice was sometimes barely audible, he told us his life story. Sadly, this was our last meeting. A few months later, my sister called to say that Mr. Anderson had died.

Between the photographs and the interviews, I had received an enormous education. Before I met Mr. Anderson I knew nothing about the way blacks and whites lived in Mississippi between the end of slavery and the beginning of integration, side by side, and still separate. By the time I came along, schools were integrated, but our rich black history had been lost in the process. Through Mr. Anderson's photographs, I learned about a world that was segregated, self-sufficient, and full of pride. Ironically, Mr. Anderson had recorded our version of the American Dream.

Slowly I began to share my treasure. I met with a series of gallery owners, museum curators, and dealers. One step led to the next, until I reached Charles Schwartz, a photography dealer and collector.

The day we met, I carefully selected my favorite photographs, and took a cab to Charles's office. Normally I take the subway, but today I carried precious cargo. I nervously rode up the elevator, and when the door opened, Charles greeted me. I liked him right away. He had a funny energy and wild white hair that reminded me of Albert Einstein. He welcomed me into his penthouse office, which must have one of the most beautiful views in New York City. As I looked out at the skyline, I thought to myself, this will work, this has to work, he is the man!

I studied Charles's face as he looked at the photographs, but couldn't tell what he was thinking. He selected a few photographs — but they weren't my favorites. Then he turned to me and asked, "What else do you have?" This was not what I expected. But I quickly

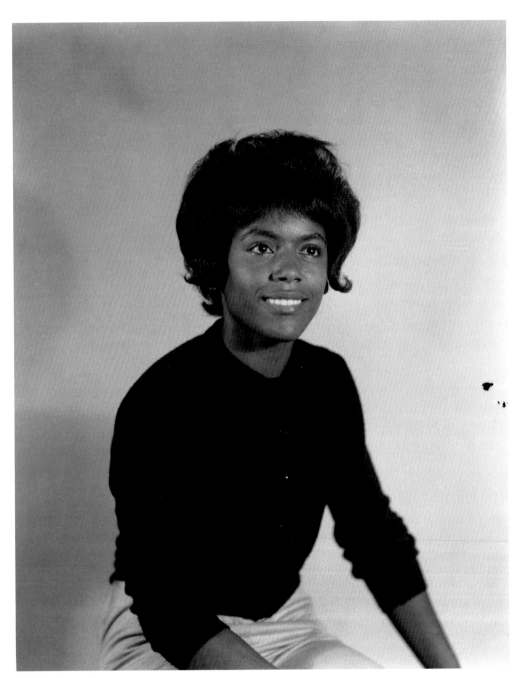

The found portrait

answered, "I have a huge collection of negatives and photographs. When can you come to my apartment to see them?"

On the next visit, Charles asked if he could borrow a few negatives and make some new prints. They turned out even more beautiful than we had hoped. For the first time I could actually see the photographs, and the project really seemed to come to life. Finally Charles said, "I might be able to work with you. We might really have something here." By now I was so curious that I shouted, "What is it? What do we have?" "I don't have the answers," he said, "But together we can find out. The pictures will tell us what to do next."

Four years later, it has been a long, exciting, and sometimes frustrating process. On an unusually warm February afternoon, I was summoned to Charles's office. There had been a mishap, something about the book. On my way uptown, I felt a bit miffed. When I arrived at the office, I learned that some negatives we needed for the book were missing, and I frantically began to search through every box and every binder, even the ones full of faces that had never been identified. And then suddenly there she was, her big, beautiful smile, head tilted to the side, staring out into space "That's my mama!"

PICTURES MADE ANY TIME, ANY PLACE, ANY SIZE

H. C. Anderson

The Anderson essays included in this book come from two interviews conducted with H. C. Anderson, the first in 1977 with Daisy Greene, for the Washington County Oral History Project, and the second with Shawn Wilson, in 1998, shortly before Mr. Anderson's death.

I WAS BORN JUNE 12, 1911, IN NITTA YUMA, MISSISSIPPI. MY MOTHER'S maiden name was Charity Dean, and my father was Frank Anderson. I was reared up in Hollandale, and I lived there until I was a young man. Professor E. P. Simmons was my first teacher, my favorite teacher. He taught sixty years at the Hollandale School. I take great pride in thinking he was one of the best teachers of our people in the State of Mississippi. Professor Simmons always taught the boys to try to challenge themselves. And I accepted his challenge at an early age.

Professor Simmons talked about voting a lot. He talked about our people not having a vote. And he was talking to a group of small boys, about eight, ten, twelve years old. At that time, you couldn't do much and [have] it not be known, but he taught in a way that would get things over to the children and to their parents also.

The first piece of property we bought was Mr. Simmons's idea. He would say, "Boys, tell

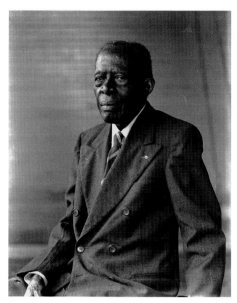

Professor E. P. Simmons

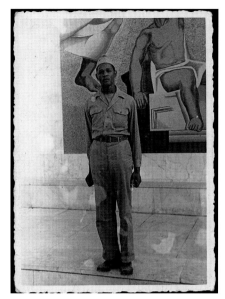

H. C. Anderson in uniform, circa 1945

your parents. Ask your parents to buy a small piece of property, [so they can] register, and vote." He said, "If you vote, you'll have a voice in what's happening, but if you don't vote, you have no voice." He said, "You also could be elected. If you want to be the mayor of the town, if you get enough votes, you can be elected mayor of the town. Or even president of the United States if you have a vote large enough."

We finally bought a piece of property in Hollandale, and my parents started to vote, early. As soon as we reached the age that we could vote — then for boys it was twenty-one years old — we were out there trying to vote. In all of the little towns we had just a handful of people who could vote. Hollandale had only Professor Simmons, his wife, and three or four more other blacks. Greenville didn't have many voters. Greenville had such a few voters.

I began teaching because of Professor Simmons. After I graduated high school, I attended Jackson State College, but left after only one semester because my health was very poor. One day, Professor Simmons sent for me and said, "Boy, I would like for you to teach school." I entered Summer Normal in Greenville, and took the test for my license in Belzoni. The Superintendent of Education in Washington County assigned me to a school east

of Hollandale. The following year he made me a principal and sent me out to what was known then as Houston Plantation. Then they asked me to teach in a new school somewhere between Hollandale and Belzoni, but I worked at the Hollandale Compress instead. I could make twenty-six dollars a week at the Hollandale Compress. When I started teaching school I made twenty-six dollars a month. Later, Mr. Simmons sent for me again. Athletics had become very popular in black schools, and [because I was] a good athlete, Mr. Simmons asked me to come back to teach with him. I accepted. This must have been about 1937, because I taught at Hollandale School five years, until I went into service in 1942.

After going into the service I decided that it had to be somewhat easier to vote. I tried to get as many people on the books as possible — qualified voters. Around 1963 I had contact with the Southern Christian Leadership Conference in which Dr. Martin Luther King was the leader. I worked. At this time, citizens had to pass a literacy test in order to vote. I established an adult class in my home. We were finally able to help about a hundred pass the literacy test.

Segregation — all my life it caused me to wonder. As soon as I was big enough to think a little — why, why would one person be better than another? Why wasn't I . . . as good a little boy as a white boy or a white girl? . . . Why were they given so much . . . everything that was needed for them, and I was just thrown away and nothing was cared about me. Why couldn't my parents be at the head of the operation as well as the whites? Everything was white-controlled . . . and I certainly didn't like being controlled altogether by whites. I could stand it, but knowing I should have the same privileges as any other child did, it hurt me.

If whites were walking in the middle of the street, we had to find a way around, especially white women. Police abused me. We heard about slavery, it was mean, but this was almost as bad as slavery could be. I don't think it could have been much worse. You felt that they had let up a little on your segregation [when] you could use a rest room, [but] it just felt wrong. You just knew it was wrong. In most cases where the rest room said, White Only, everything was clean. In the black rest room they didn't care how much trash and everything got around. It was just bad. Most of the time the black commode was broken or something was wrong It's a great improvement today, yet it's a long ways from being correct. It's a long ways from a black man receiving the same treatment a white man receives.

During the Civil Rights movement I did a number of pictures of marches that lasted several hours, two and three miles long. They marched from Alexander Street downtown, and on Nelson Street, the principal black street. On one occasion something happened on the

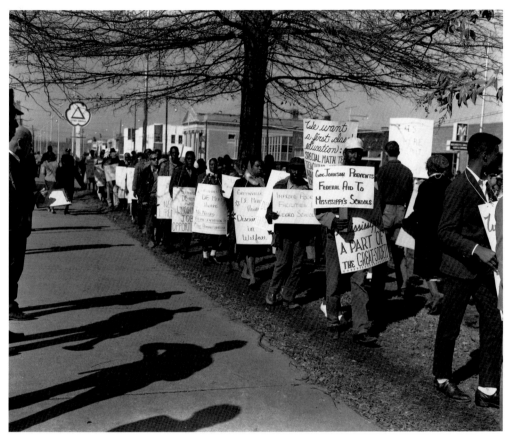

Marching in Greenville

city hall steps. There was a scare put out — blacks not wanted — but blacks marched down the block where city hall is, and policemen were all around us. I had a fearful time there because although I made pictures of them, I had fear that they were going to pick me up and take me to jail, or charge me with something. But I didn't get charged with anything.

At that time our ministers in Greenville were very backward. But being a minister myself, one of the things I did, I spoke up. And I decided that if white people could hold office, I wanted to hold office too. Black people had organized a Freedom Democratic Party in Mississippi, in Jackson. It was very important to organize the other party, and I made pictures at a meeting, showing the groups from different counties. One of the leaders of the

party was Miss Fanny Lou Hamer. Miss Hamer was from a little town north of Itta Bena. She could sing. Dr. Aaron Henry had come to be a representative from Clarksdale. It looked like the meeting was dying on them, but Miss Hamer wakened the group and sang a congregational song, "Go Tell It on the Mountain, Over the Hills and Everywhere." I took Miss Hamer as she sang. I can't recall all the names, but the Negro leaders in Civil Rights work were there. Miss Ella Baker was there.

In 1965 I decided to enter the city council race in Greenville. I announced it about a year and a half before trying to run. The election came on December 13, 1965. I ran as a Freedom Democrat in the general election. I had the choice of running as a Democrat, but because I knew I would lose in the primary, I decided to run in the general election. Before

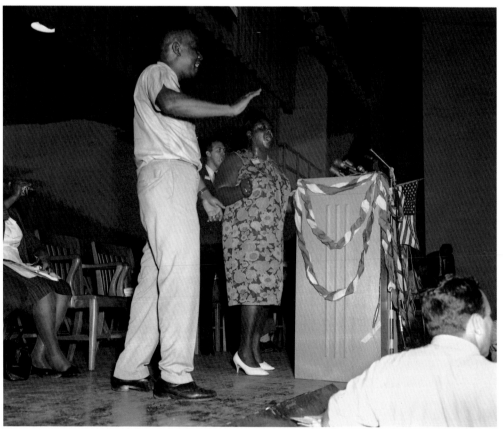

Fanny Lou Hamer and Aaron Henry at an early F.D.P. rally

that time, Washington County had only had primary votes; they never had a general election. We had only about 3,000 voters in Washington County at that time. Whites had upwards of 10,000. But I decided to run. On the general election night, ballots were being announced. I knew that I had lost before I won one tally. But we did after all get a very nice vote in '65.

I had my wife take this picture. It's one I used in seeking office because it brings out my expression, and shows I'm serious about what I'm doing. I really think I've been serious all my life. I wasn't a quitter. Anything I wanted to do, I continued. I would go through the best I could. When I was young, in school, I put a lot into it, and I was able to teach at Simmons High School, in Hollandale. I enjoyed teaching. I went into church work, ministry. In my

The campaign portrait

life as a boy, I wanted everything that anybody else could have that was good for me. I wanted to treat others right, but I also deserved being treated right. That's one of the reasons why I pushed so hard.

I received my first camera when I was about nine years old. The first photos I took were at Drew Plantation just north of Hollandale. I tried to catch pictures of people, cats, trees, houses, whatever was interesting to me as a little boy. If I had a special little chicken they call mine, I would want to take pictures of that little chicken. I made pictures of birds and where the birds lived. I made pictures of hogs in the hog pen. My associates called me the box cam-

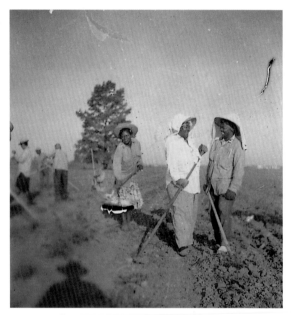

On Drew Plantation

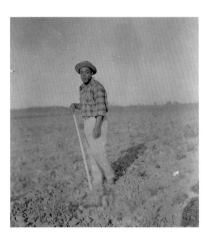

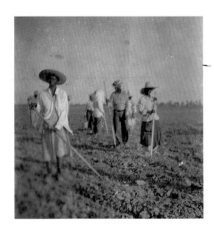

era champion, because I made pictures that looked somewhat professional. My younger brother Cordoza and myself began to make pictures around Hollandale of people's homes, and, as little businessmen, we had a little printing set. On the back of the pictures, we would put "Anderson Photo Service." That's the name I chose for my business after the war.

I studied photography on the GI Bill. I learned about it when I returned from overseas. I was on the sick list, and while I was recovering in a hospital on Long Island, a master photographer, a lady, came out and gave a demonstration. She told us about the New York Institute of Photography. I really became interested, and wanted to go there. But mother and father had lost their house in a fire, and my mother was rather badly burned and my parents wanted me to remain home. So we searched for a school close by — during segregation there were no schools in Mississippi that taught photography to black people. Finally we found Southern University in Baton Rouge, and I enrolled there in September 1945.

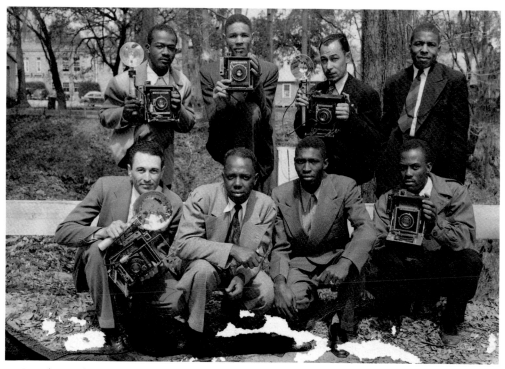

H. C. Anderson (back row, second from left) and his photography class at Southern University

At that time you couldn't easily buy a professional camera, but my instructor knew some photographers who had one for sale, and my brother loaned me the money to buy it. It was a three-year course but I finished in less than two years. I saw it as on-the-job training. Among the twelve students I rated at least second best. After I completed the course I wanted to study color photography, but Mr. Bahne of Memphis Photo Supply persuaded me not to. After examining some of my work, he said, "Young man, [you] don't need to wait. You're a good photographer now. You should go into business and then later, maybe take a course." He said it would be a number of years before color would come into reality. I found this to be true.

My wife and I moved to Greenville in 1948, when I decided to enter the business of photography. Greenville offered a better opportunity than Hollandale did. I met my wife on a bus

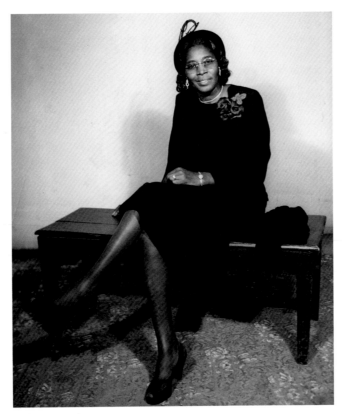

Sadie Lee Anderson

riding between Hollandale and Greenville where I was going to get some pictures. Busses were segregated. Most of the seats were for whites, one or two seats in the back of the bus left for blacks. We had to stand all the way from Hollandale to Greenville, and the bus was rocking, and I helped hold her up a little in the aisle. That's where we started talking. We talked until we got to Greenville, and when I picked up the pictures I gave her one. From that instant, love happened. She took so much interest in me. I think most of the love was on her part, but later, I found out that I had such a lovely wife. We were such a sweet couple. She became very interested in pictures, though I didn't know this until two or three years after I had been in business. My wife was an observant person. She observed, and just by observing, without me giving her a chance to even use a camera, she learned. Maybe later she asked me a few questions about why you use certain apertures and other things. I taught her a little.

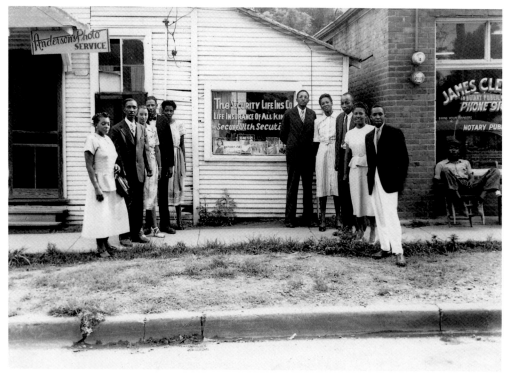

Anderson's first studio on Nelson Street

I entered business in Greenville in 1948, on Nelson Street. My brother was there as manager of the local office of Security Life Insurance Company, along with James Carter's Cleaners, Brown's Pastry Shop, Mrs. Bailey's Café, the Casablanca. There were many others, but these were the most important ones. (Nelson Street isn't thriving now. It doesn't seem to be of interest. It seems to be a place where the morals have been let down.)

We did black-and-white photography, making and processing all our own work. When I started, Mr. Louis Gibson had all the work in Greenville just about sewed up, but being just fresh out of my course I thought that I had more theory than Mr. Gibson . . . and finally I had practically all of the Greenville black business. But I have not confined myself to black business. At one time I did almost all the passports from Greenville for all races. There also were two white while-you-wait photo places on Nelson Street They offered me a job when I came out of school, but I've always wanted something that I could call my own. The place had a black helper, and they were very nice to the help, and the help made [photographs for] black people. The pictures they made for us were direct positives, pictures that you snap and carry through a developing solution. You let it dry and you only get that one picture. But we used a negative process, and from the negative we could produce a hundred pictures, as many pictures as we desired to produce. When I went into business [you could buy] direct positives two for fifty cents or three for a dollar. When I came out using a negative process we started out a dollar for a picture, three dollars for three pictures, and at that time our people didn't know the difference in the type of pictures. But they found out that our pictures would last, where the direct positive would only last until it got wrinkled or beat up. Where this man was producing one picture, in the same length of time we could produce ten pictures, or fifty. Actually I have some black-and-white pictures that were made forty years ago and they almost look as though they were made yesterday.

At one time I made photographs at most all the large weddings in Greenville. I also made pictures of the school, a number of activities at the school, athletic teams. I worked one special job for Mississippi Vocational College at Itta Bena, and from that special job I worked for them for three years, more than three years.

Coleman High School was the first real big job I attempted in Greenville. I believe in 1949 I was asked to bid on the Coleman High School Yearbook. That first year I worked together with Mr. James Robinson, over at Indianola, and from that year on I worked as photographer for Coleman High School. I believe that I have made pictures for all of Coleman's homecomings from 1948 through the 1950s.

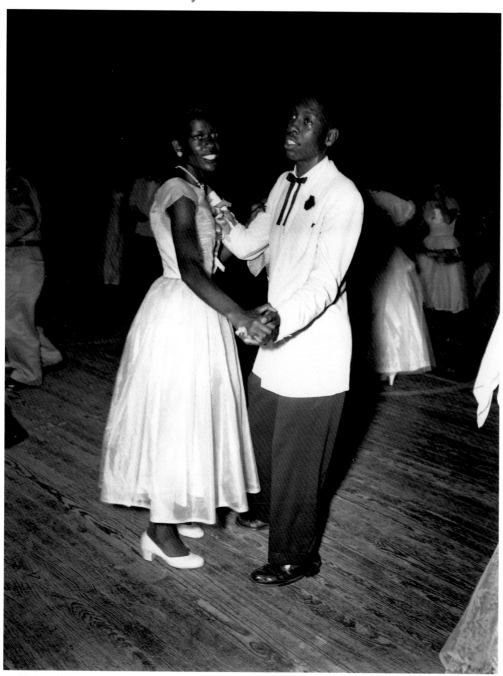

Coleman High School prom

I made parade after parade of Coleman High School, homecoming parades, other occasions. I did a lot of pictures. Mr. Huddleston used to be leader of the Coleman High School Band. When we'd take a band marching for Mr. Huddleston, we showed the one who was in step and who wasn't in step. . . . It was a joyous time.

My wife and my daughter helped me greatly in photography. On big jobs, my wife would keep records of who we were making pictures for, the cost, and how much money we were taking in. At the prom, some nights we would make a hundred different pictures for different groups. My wife would act as the treasurer or the money keeper, and my daughter would act as secretary. They both were good helpers. They worked so well with me. In the time we were making mostly high school pictures, my daughter was a high school student,

Inside the studio

and knew most of the young people that we were making pictures for, so she kept the books and my wife kept the money. It was not what I did altogether, but what *we* did.

When I retired, a young television reporter asked me what I thought [of] my work. I answered, "I think you know the photographer by the pictures, and when you see these pictures you'll know whether I was a good photographer or not." So we got a box of pictures, and began to lay them out. Some were very early. It was even hard for me to believe I made the pictures, because they were of such a good grade. You forget about what you see but a picture always keeps you in memories of what happened. I feel proud of some of the pictures I made. I made pictures of things that to me were amazing.

There is a real mystery in the way a picture is made; the type of light that will produce a picture; the production of pictures in the dark room; how you could expose the blank paper, put it in the developer, and watch the picture come up in the solution. It was a just mystery, and a lot of amusement to me.

To be able to make a picture that would satisfy a customer always meant a great deal to me — not my satisfaction, but their satisfaction. If you can take a person that you'd call ugly, and make him on the picture a good-looking person, then you are doing a good job. I specialized in makeup. To make up the face with powder, smooth out the skin, to be cautious about glare and light where sweating and other things cause spots to be in pictures. I just decided that I wanted to make good pictures and wanted good, satisfied customers. And most of my people have been satisfied

If a young person asked me today, I'd tell them that photography is a very serious field. If you don't have a great interest in photography, you will not make a good photographer. A photographer understands that the picture will show what is in the person. And if you're not interested, you will not draw out what you should draw out. You must realize that making pictures is a lot like telling a story and you've got to tell the whole story. But I'd be happy to say this is a great field. If someone desires this trade, he should try to make the best out of his photography, try to make the best pictures, try to bring out more, try to show what really happened when the picture was made. Try to show not the picture only, but show the person who had the ambition. And if he's showing it, he shows himself.

AS IF WE WERE THERE . . . REMEMBERING GREENVILLE

Clifton L. Taulbert

It was early morning in New York City, drizzling rain outside, and I was determined not to get soaked as I prepared to leave the graceful old Warwick Hotel for the offices of PublicAffairs, where I would meet Shawn Wilson, a black New Yorker with Mississippi roots, and Kate Darnton, a PublicAffairs editor, to view a collection of old photographs.

As I stepped from the elevator into the lobby of the wonderfully restored old hotel, I felt a surge — the bustling excitement of New York City. The lobby was filled with people, all in a hurry and plenty of excitement to spare; spirits not a bit dampened by the rain outside. I felt the light touch of the doorman who politely handed me an umbrella, one that was still in its plastic packaging. New umbrella in hand, I swung out of the revolving door and into the throng of businessmen. As I turned onto 57th Street, I chuckled at the irony: Here I had come all the way to hustling, bustling New York City just to travel back to my hometown of Greenville, Mississippi. What a thought.

I had never heard of Shawn Wilson before he called me several years earlier. Over the phone, he was breathless with excitement. He went on and on about some treasure he had

uncovered while home in Mississippi. I heard something about photographs. I heard "negatives," but I still wasn't sure exactly what this young man had discovered. I finally managed to calm him down and piece the story together. Shawn had been raised in Greenville and upon one of his trips home to visit family and friends, he had met Mr. H. C. Anderson, the city's noted "colored" photographer. As far as I could tell, Shawn had gone to Anderson's studio with only one purpose in mind: He was trying to get a master print of an old Anderson photograph of his deceased mother. But as he sat with Mr. Anderson, their conversation grew beyond the faded portrait. The aged photographer, still filled with pride in his work, rather innocently showed Shawn some photographs he had taken many years ago of Greenville's black citizens. In so doing, he introduced Shawn to his own past.

Now, it seemed, the photographer had passed away and Shawn wanted to know more about the world he had glimpsed while visiting the old man's shop. He wanted to talk to me about Greenville. He had read my writings about the South and he thought I could help him make sense of Mr. Anderson's strange and wonderful photographs, which were now in his possession. Perhaps we could even collaborate on a book. Would I consider being involved in the project?

Though I accepted his compliment about my writing, I still didn't know Shawn, nor had I seen the photographs. I did know Greenville, though, and could understand this young man's fascination. Greenville was an unusual city. During the height of legal segregation, it boasted a proud, well-heeled black middle-class community. I know. I was there to admire it. As a boy, I had witnessed what young Shawn Wilson had glimpsed in the photographs: the upstanding, even glamorous lifestyle lived out by Greenville's colored citizens. But while I was touched by Shawn's open enthusiasm, I was not yet able to make his vision my own. I think I agreed to talk more about the project just to get him off the phone. I really did not expect to hear from him again.

Years passed and so did my memory of the conversation with the young man from New York. So I was surprised when, out of the blue, I received another call from Shawn. This time his voice was calm. I could hear every word enunciated with great clarity. Shawn's dream had become a project with a plan. A partner was now involved and a publisher had been obtained. Shawn wanted to know if I was still interested in helping him. I was intrigued that he had persevered and that he had kept my number. I reaffirmed my interest, though I was still unsure Shawn's photographic discovery was really worth anything. I went ahead and gave him permission to pass my name on to his publisher and again expected to hear nothing further.

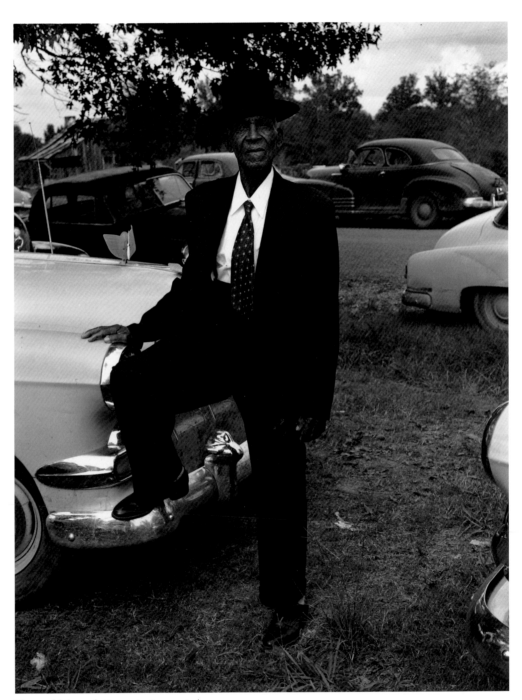

The world through Poppa Joe's car window

This time it was different. Within a short period of time I received a call from Kate Darnton, an editor at PublicAffairs. She informed me that my name was being considered along with others to contribute an essay to a book they planned to publish. The book was about Greenville. Our conversation was interesting, but certainly noncommittal. From my perspective, Miss Darnton's call was more of a courtesy; she was simply responding to the wishes of her client, Shawn Wilson. I really did not expect to hear from her or about the project again. After all, she was nestled in New York, where good writers sat in coffee shops on every corner. I hung up the phone satisfied at knowing that the photographs of colored Mississippians, many of whom I might have known, had captured the attention and the imagination of such a well-respected publishing house.

But Kate Darnton did call back. Shawn Wilson called back. They wanted me to be part of the writing team. And now, several years after that original phone call, here I was in New York City, on my way to finally view the photographs that had stirred up so much interest.

I have always loved Manhattan. I love Broadway. I love the dizzy mix of thousands of diverse people. But this trip was generated more by my love of Mississippi and my fond memories of Greenville than my attachment to New York. As a boy growing up in Glen Allan, a small cotton community some thirty miles outside of Greenville, Greenville was the big city. It was exotic and sophisticated with its wide streets and multistoried brick buildings and big-city living, its shiny cars and fancy-dressed ladies. For me, driving to Greenville was tantamount to taking the Concorde to Paris, France.

I was anxious to meet Shawn and hear more about his discovery, not just of the photographs, but of a way of life that had eluded him. Meeting Kate Darnton, the editor, was also very important to me. I wanted to understand why she was so enthralled with the project. Her enthusiasm for the book had come right through the phone lines. She seemed delighted over the discovery and the part she would play in bringing the pictures of these African Americans and their life to the attention of the world. I could understand Shawn's excitement — after all, it was his mother's faded portrait that had started this whole journey — and I could understand Kate's — this was a whole new world to her — but it remained to be seen if Mr. Anderson's pictures would have a similar effect upon me. Would the photographs do justice to the memories I had of Greenville? Would they be affirming or disappointing? Had Mr. Anderson captured the charm and the magic of the Greenville I remembered?

While making my way to Kate's office, my own private pictures of Greenville kept flashing though my mind. I was remembering the times when my great-grandfather, Poppa Joe,

would drive me to Greenville in his '49 Buick on Saturday mornings to get frozen custard ice cream and hot French bread. On those rare Saturday mornings after our shopping, Poppa Joe and I would venture into those neighborhoods where the colored professionals lived, the streets north and east of Main Street and Washington Avenue. I would press my face against the car window, staring at the homes on Alexander Street where the grass was manicured and where concrete driveways were lined with shiny cars. Occasionally I would see their owners all got up in suits and pretty dresses leaving their houses for a Saturday shopping spree. Their lives were so different from ours in Glen Allan. There were no brick homes for "coloreds" in Glen Allan. There were no sidewalks or green lawns. Our churches were simple wooden structures, small enough to fit inside Greenville's large brick houses of worship.

Would any of the people I saw from Poppa's car window be in the photographs salvaged from Mr. Anderson's studio? Would I see some of Poppa's preacher friends? Or Cousin Saul's fancy neighbors? What would I find? What did I hope to find? Would I get an inside peek at Greenville's elegant "front" rooms and colored social clubs? Or would I be disappointed? Maybe the Greenville I fell in love with some thirty-five years ago would now seem backward and small. After all, the images in the archive of my memory were those of a boy, a cotton kid dazzled by the strange smells and sights of the big city.

Still, I knew that Mr. Anderson's pictures would offer an uncommon view of southern black life. Most images of black Americans in the Delta were formed through the lenses of photojournalists. Northern photographers had come south in the middle of the century to document the plight of blacks, the survivors of slavery, reconstruction, Jim Crow, legal segregation, and the Civil Rights fights. They captured our tears. They recorded our terror. They took pictures of our dilapidated tenement homes. They caught our mothers without their hair freshly pressed and without their makeup applied. They caught our uncles and fathers at the end of the workday, wearing dirt-smudged work clothes and weary faces. Rarely if ever were the out-of-town cameras around on Saturday and Sunday afternoons when southern black communities like ours were at our best. They were more interested in the cruelty of Jim Crow.

I finally made it to the thirteenth floor. The young man at the desk was expecting me and immediately set out to get Kate. It was only nine, but Kate was full of energy and excitement. She assured me that the photographs would be forthcoming, as would Shawn Wilson, Peter Osnos, the publisher, and several other people. In the meantime she showed me

to a conference room where I was made to feel at home while I waited. For a few minutes, which seemed like hours, I sat alone in the conference room, reading the prints on the walls. I could overhear conversations from the hall; other people were on their way. The door to the reception area opened and I heard a rather familiar voice. It was Shawn Wilson. He was much younger than I thought and obviously from a different time period than myself. He had grown up in a somewhat integrated Greenville, whereas for me, it was a totally segregated city. Now, with his charcoal gray suit and shaved head, he looked more like a Ralph Lauren model than a Greenville boy. But his wide smile and slightly lilting accent belied his Mississippi roots. We shook hands. While we were reintroducing ourselves, Kate quietly slipped in, several thick black binders under her arms.

The room was filling up with people, all of whom had been drawn together by the pictures of the old black Mississippi photographer. We were quite the mixture — young and old, black and white, male and female, southern and northeastern. I was introduced to a rather distinguished looking white gentleman, Charles Schwartz, Shawn's business partner, and then to Peter Osnos, the publisher of PublicAffairs, and Mary Panzer, an archivist and historian.

Kate and Shawn were the youngest of the group. According to them, Anderson had captured a side of life that defied legal segregation and showed the resilience of black people. But they needed my input to support their thesis. I was the only one who had lived through the rigors of Jim Crow. For them it was a dark period in history, but for me, it had been a way of life. Shawn had grown up in Greenville, but he was a son of legal integration, which had redrawn boundaries and dismantled much of the supportive and viable infrastructure that gave birth to Greenville's colored middle class. Greenville changed dramatically in the 1960s and he knew very little about the seemingly comfortable, dignified lifestyle that poured forth from the stacks and stacks of old pictures. I was the only one present who had lived during those times and carried memories from what I had seen and heard. I was the only one who knew that such a world had really existed.

Before we opened the binders, we talked about Mr. Anderson and the unique position that he had in history. Mr. Anderson had preserved a way of life among colored Greenville citizens, and in doing so had achieved somewhat of a reputation in the colored community of Washington County. In many ways, legal segregation had provided him with the opportunity of a lifetime. Colored life was lived independently from broader society. So restricted were many of the social barriers in Greenville that people of different races could live just a block apart and never get an inside peek at each other's lives. African Americans knew

more about white life because they often worked as maids and butlers in the homes of their white neighbors. But colored people received no white visitors in their homes and they were not sought out by white photographers. This left an entrepreneurial opening for the likes of Mr. Anderson, whose photographic skills matured along with the economic upswing of his colored community. He became black Greenville's "official" photographer-in-residence.

Catching his neighbors at their best was Mr. Anderson's job, one that he handled with great pride. He would pose his subject, add a bit of flair, and snap away. Little did he know that some five decades later, a group of people in New York City would use those pictures to relive the Greenville of his day, just as he saw it, glossy and inviting. I sat quietly as Kate laid out the black cardboard binders with hundreds of plastic sleeves that contained proof positive of Greenville's colored middle class. I watched carefully as the very first photograph was unclipped from the binder and passed across the table as if to say, "Here we are." And that very first picture emerging from the file captured all that I had remembered and admired of Greenville. I held the photograph in my hand, examining the stylish black couple. They were posed carefully on two wood chairs and gazed into each other's eyes as if quietly waiting for the sound of Nat King Cole to drift through the window.

"Look at the turn of her ankle and look at the proud face of the man. These are the people I would see in Greenville when I went shopping with my great-grandfather," I said. Before the others could respond, I continued, "Look at the graceful lamp, the carved table, the wood floor, and the curves in the back of the chair." I could feel myself being drawn into their world.

Then, peeking out from the pile of pictures, a small black-and-white photograph caught my eye and instantly made my trip to New York worthwhile. It was Miss Ann Britton. I almost yelled out, "I know her!" Miss Britton was one of our important colored educators and the wife of a prominent dentist. As the Genes Supervisor for Washington County, she provided professional training for rural black educators. I remembered her as a caring lady, one of the persons who encouraged my mother to go into teaching. So real was the photograph, I could almost hear Miss Britton's proper voice emanating from the print. She was seated on a bench in what looked liked Mr. Anderson's studio with her classic face held high and a careful smile frozen on her lips. She was a beautiful lady, who carried both European and African genes with pride and dignity.

As I held the photograph, I imagined Mr. Anderson saying, "Now Miss Britton, just hold your head a little to the left so that the light will catch your smile." She did just that.

As more pictures poured out of the binders, the conference table was turning into a southern mantelpiece, graced with the smiles of a community who had defied Jim Crow. The reach of segregation, though harsh, had not been able to accomplish its ultimate objective. It was not able to humiliate the colored community. Greenville's blacks bonded together, creating an entire self-sufficient black city with its own restaurants, its own schools, its own churches and nightclubs. These were a proud people. These were a people who worked hard to enjoy the comforts of middle-class existence. They lived in style. And they built a strong community of like-minded colored folk around them.

I glanced over at Shawn. His face could not have been brighter as he fingered the pictures of the people that represented a time in history he had not known. His eyes became the eyes of thousands of other African Americans searching for memories of their parents' lives. Without a doubt this was a moment of validation for Shawn.

I could only shake my head as I leafed through the pictures, all meticulously depicting a world that I had left behind. Thanks to the photographs, I would no longer have to question my memory and Shawn would no longer have to search for his history. Here was the world I saw from Poppa's car window. It really did exist.

As we passed the pictures around the room I asked, "Did you all ever imagine the existence of such a people during that dark period in America's history?" And they all said, "No." Their view of segregation was formulated by the roving photojournalist who had depicted only the struggle in black southern life. Those cameras forgot to record the stories of our resilience and triumph. They forgot to record our weddings and celebrations. I wanted to rush through the pictures all by myself, but I felt it was important for me to stop and tell these New Yorkers about Greenville and the normal, civilized, everyday life of its black citizens. So I asked for a few minutes to take them back with me to this beautiful southern city on the Mississippi River.

GREENVILLE, THE MAGIC CITY ON THE RIVER

Growing up in a small, dusty Delta community in what appeared to be an endless sea of cotton, I would often find myself daydreaming of a magical nearby place, Greenville, the Queen City of the Delta.

The Delta was a place where the sun reigned supreme, where the humidity wrapped us

in dampness, and where, for the most part, Jim Crow laws defined the social order of our day, telling us what we could and could not do. Cotton was still in the royal family when I was a young boy growing up in Glen Allan with my great-grandparents and great-aunt Ma Ponk. Except for colored church work and maid service, fieldwork was mostly all that was available in small black communities like ours. And for those of us who chopped and picked, those rows of cotton were seemingly without end. Our landscape was one of open fields interrupted only by rows and rows of tenant homes called shotgun houses. These were small homes, mostly two rooms with an outdoor privy to service nature's call. We were a working people and the purses of the plantation owners bore witness to our diligence.

However, the weekends came when we fled the fields. In our small cotton communities, we had our Saturday nights when the juke joints would be crowded to bursting with long-legged women and strong-backed men, who gracefully gave life to the blues. But in our eyes, there was a faraway look to another place. Glen Allan could not hold us captive. We knew of a place with people who looked just like us, black people who lived a life that was exciting and inviting. For us in the rural area of Washington County, the place was just up the road apiece. Not too far from my world of cotton picking and dreaming, life changed, the gravel roads gave way to smooth blacktop highways, leading to Greenville, the city of dreams.

Greenville defied many of the images of black southern life as endless rows of cotton, beleaguered field workers, rundown houses, and broken families. In the midst of this southern society legally divided by race and ethnicity, poverty and wealth, education and struggle, Greenville fostered a community of colored professionals. Greenville provided proper-talking teachers who drove their nice cars to small towns like mine to teach the local children. These were our colored educators. On the classroom walls, they proudly hung their diplomas from Fisk University, Alcorn College, Tougaloo College, Jackson State University, and even some from colleges up north with names I could not pronounce. In Glen Allan, we would only see several of such people at a time, whereas in Greenville, there were whole neighborhoods populated with college and university graduates. Greenville had the smartly dressed funeral home directors who added an uptown touch to our dearly departed. It had the preachers and the deacons of the large colored churches who came to small communities like Glen Allan to hold revival. It had the colored doctors who sent their children to private schools. It even had colored postal workers in uniforms. And then there were the Coleman High School athletic teams and the band, which had the prettiest dancing girls in

the world. These were the people who secured their place in history each time Mr. Anderson, Greenville's colored photographer-in-residence, came to take pictures of their gracious living. In the midst of this legally segregated and often humiliating world, Anderson freeze-framed their comfortable middle-class lives, holding our dreams up high.

The heads around the conference table listened attentively to my account of black southern life. My comments only whetted their appetite for more stories. I reminded them that Mr. Anderson showed us Greenville's colored middle class from his vantage point. The travelling photojournalists had missed the colored medical auxiliaries, the well-dressed wives of black doctors who proudly framed their degrees from Nashville's Meharry Medical School. The out-of-town cameras missed the colored couples who had two sets of clothing, one that they worked in as servants and the "good" set that they wore among their friends and families. Fortunately for Shawn Wilson and now for all of us, Mr. Anderson was right around the corner with his camera in tow, recording their lives from birth to death. He had no idea that he would become their historian. This New York project could potentially give his pictures and his forgotten people a place of permanence in the memory of America.

I watched as the pictures slowly made their way out of the binders, forming a pile of life right in our midst. The people at the table held each picture as if it were a great treasure, careful not to ruffle the silk dress or leave a fingerprint on the baby grand piano. I saw in their eyes and heard in their conversations the wonder that comes from discovery. I listened as they asked questions: "How could we have missed such good living?" "Where did these people come from?" I understood their curiosity and bafflement. All their lives they had heard about the South and the plight of the poor colored people who worked the fields and lived without physical luxuries or cultural stimulation. Now pouring out in front of them was proof of a story not told. How was it that these beleaguered people, who had surely suffered harsh work conditions and ridicule, could have created for themselves and their families such gracious lifestyles, not unlike the comfortable postwar lifestyle of their own white parents and grandparents? In the midst of one of America's harshest and most racist periods, here were African Americans carving out a memorable and dignified life. How did they do it? I felt their eyes focusing on me. I had lived part of what Mr. Anderson's camera had captured. What did I think?

I sifted through the images of beautifully dressed women and proud men as I attempted to respond to Mr. Anderson's view of Greenville. I knew of this middle-class world and its people. I had seen them on my Saturday trips to Greenville with Poppa. I had

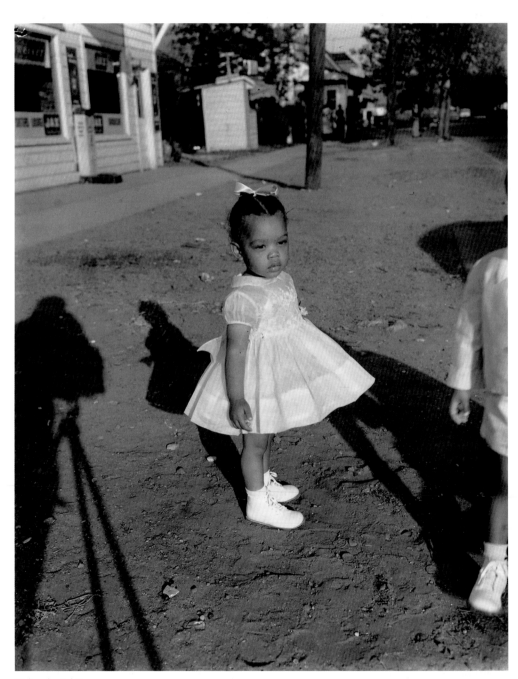

"A lovely sight"

admired the colored teachers and doctors strolling down Washington Avenue. Poppa had often pointed out their big brick homes. But I was still from Glen Allan. These photographs were taking me inside those elegant homes, inside those private lives I had dreamed about as a cotton-picking child. I quietly and reverently picked up the photographs one by one, peering into the faces of the fancy black people with their heads and bodies turned just right.

In truth, this wasn't my black South. It was better. Rather than talk about the people in the pictures, part of me wanted to take the photos home and set them up on my mantel so that my son and our guests could see the world that I had seen and admired as a child.

BABIES AND YOUNG CHILDREN, AMERICA'S FUTURE IN BROWN AND SEPIA TONES

As I picked up picture after picture, I was struck by the number of photographs of bubbling brown babies held just right for the camera by their moms and dads or grandmothers and grandfathers. Like other adults around the world — and people in far better circumstances — the proud parents in Mr. Anderson's Greenville made sure that their children, the symbols of their future, were perfectly presented for all the world. Their steady expressions told us, "This is my future. This is my hope."

A mother holding her little black baby stared us in the face. I knew this image by heart. It was more than a picture to me. It reminded me of my own mother and the pride she took in having our pictures taken — and how cherished those pictures were. The crispness and sharpness of the photograph brought the young mother and baby to life. Mr. Anderson had captured cuteness and gentleness, innocence and pride all in one shot and it looked as if it had been done just yesterday.

Who would this little brown child grow up to be? Would he unwittingly follow the dictates of a society that devalued his race? Or would he become a proud professional like the smartly dressed woman who held him so firmly?

Another photograph depicted a little girl about three years old dressed in a stiff white organza dress, buckled white shoes, and a big white bow in her hair. There she stood, all brightness in the middle of a dirt street, the perfect personification of hope. So vivid and detailed was the photograph, I could almost smell the warm Delta soil and hear the buzzing

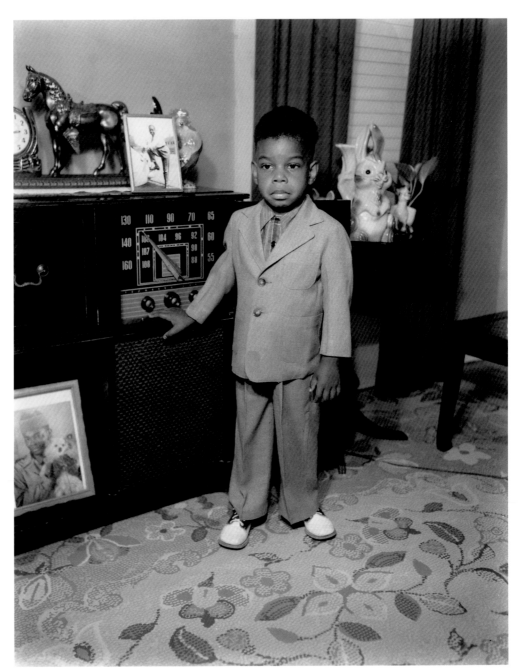

"A little gentleman"

conversation of the loving family that watched as Anderson's old tripod slowly and carefully moved in for the shot. She was a lovely sight. She seemed to be totally captivated, not afraid of the camera, allowing Mr. Anderson to capture her delicate pose. "I grew up with four sisters and they would also dress up and pose in Glen Allan, though none looked quite so elegant," I said. "This picture of youth in a white dress standing in the middle of a dirt road reminds us of the black people's faith in tomorrow. They would do everything possible to keep the ugliness of legal segregation from touching their children." Mr. Anderson and his camera were doing more than taking a mere photograph; they were recording the pride and hope.

I was so glad to see the scores and scores of photographs of children in so many different settings, all looking crisp and clean and happy and well cared for. I wanted those sitting around the conference table with me to fully understand and appreciate the importance placed upon family in Mississippi's colored world. We all know stories of the breakdown of the black family in our inner cities today, so I was especially proud of these pictures of children flanked by caring adults. "These pictures show a positive view of parenting at a difficult time," I said. "Southern blacks valued family life. They took good care of their own, educating their children, instilling them with a good moral sense." The strength of family was a way of life in Mr. Anderson's community and he recorded that vital aspect of colored living in many of his photographs. The pride of the parents came through in the wide smiles of the children. It was hard to imagine that just outside the doors of their loving homes, racial injustice and hatred were real fears. Their bright eyes never let on.

Not to be outdone by the girls, there were Anderson portraits of "little gentlemen" dressed up in grown-up style suits. One of Anderson's pictures featured a boy of about five in a single-breasted suit and two-tone lace-up shoes. His pudgy hand rests on a radio (not the kind my great-aunt had — a battery-run radio filled with static — but a full-sized radio with large speakers built into a wood cabinet). The cabinet is decorated with ceramic sculptures, framed photographs, and an elaborate clock.

"These pictures did not happen without some degree of personal difficulty," I joked, recalling the ritual of cleansing that went along with the picture-taking day. Our brown faces were ceremonially washed and scrubbed until they shone. "I can tell you these children had to look good."

For pictures, Greenville's parents and grandparents dressed their children in their Sunday best — short suit sets, ruffled dresses, and well-shined shoes. And they showcased their kids, posing them with the modern amenities that symbolized middle-class American suc-

cess — televisions, radios, telephones, lamps. These children were their hope for the future. Surrounded by loving and caring adults and many of the economic trappings of middle-class life, they were shielded from segregation's woes while being groomed to continue the type of dignified living fostered by their community. Even in communities much smaller than Greenville, the 1940s, 1950s, and early 1960s saw African American families expressing their hope in the future through the lengthening steps of their children. Mr. Anderson caught many of those steps on film. He and his camera were right there to capture those aspirations, leaving us an inside look at the everyday life of Greenville's colored middle class — elaborate childhood birthday parties, well-groomed church groups, and of course the pride of Greenville's colored community, Coleman High School, an educational beacon in the segregated Mississippi Delta.

COLEMAN HIGH SCHOOL:
THE DOOR TO THE REST OF THE WORLD

High school was very important to the colored communities. For many of us, it was as important as college. And for those of us who lived in small towns, Greenville had *the* high school for our people for years. Coleman built an incredible reputation throughout the Delta, one that demanded the photography skills of Mr. Anderson.

Greenville's colored high school, Coleman High, marked almost every child's passage to adulthood. There was one other highly respected Greenville school open to colored people. Parents who really wanted to ensure their children gained a competitive edge sent their children to Sacred Heart, a partially integrated Catholic school. The instructors, nuns and priests, were nearly all white and there was a sprinkling of white students long before integration became a way of life. Those black Greenville professionals who had enough money quietly took advantage of this unusual opportunity to give their children a leg up. But most kids went to Coleman High.

During my parents' era Coleman was the only colored high school in the area. But by the time I was ready for high school, much had changed. In small cotton communities like Glen Allan, county systems had replaced the dilapidated plantation schools and we had our own county high school for blacks just south of Greenville. Attending Coleman was a pleasure I never experienced.

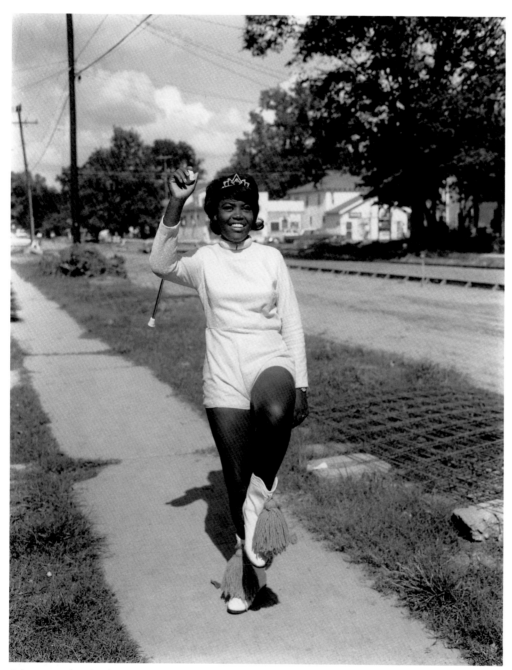

Coleman High School majorette

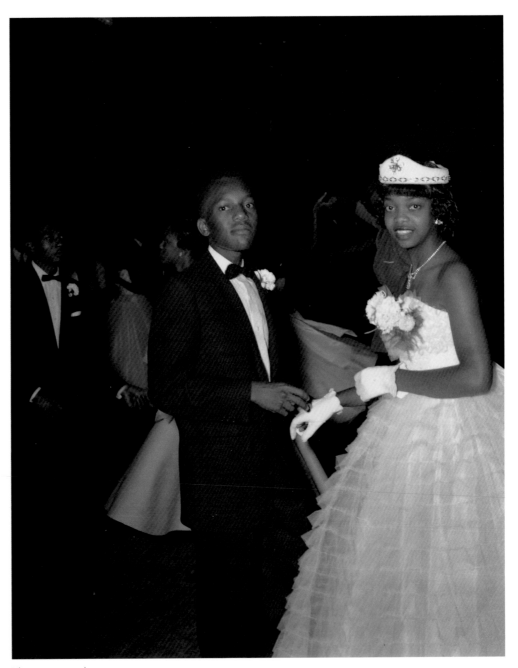

The prom couple

Coleman High reached deeply into the colored community of Greenville, extending its middle-class reputation. During the 1940s, 1950s, and 1960s, committed Coleman High educators like Mrs. Millicent Jackson were teaching pride and progress through Negro history as espoused by the noted black historian Carter G. Woodson. Many teachers focused on the achievements of blacks and their stories of beating the odds.

Anderson's subjects looked like the success that Carter G. Woodson wrote about. Shawn and I pointed out to Kate and the others the stern looks of expectation on the teachers' faces. These professionals lived right in the midst of the sharecroppers and the maids. Because their children could not attend white schools, they had created their own learning community and provided their students with all the opportunities — from cheerleading squads to science laboratories — that their white neighbors enjoyed. Education was believed to be the key to the American dream and Coleman High to be one of the doors. Historically, we all lived under the "separate but equal" school system. But despite the system's obvious inequalities — black schools were not offered adequate funds, resources, amenities, and support — Greenville's black educators did all they could to create learning environments for black students. As a result, Coleman was more like a private academy than a black public school. Parental involvement was a way of life and student performance was top-notch.

I was drawn to one picture of a serious man standing in front of the high school building. He seemed to be the principal. He was dressed in a single-breasted suit. He wore a tie, glasses, and a no-nonsense frown. His feet were firmly planted and his eyes looked into the future. The camera caught his look of care and concern, of hard work and determination. These were the type of people who would shape Greenville's colored kids, pushing them to a brighter future.

For me, going to a basketball game in the gym or walking down the sidewalk where the school property lines started was about as close as I would get to Coleman High. But now, with these discovered photographs, I was being invited for an up-close inspection of what I had missed. Mr. Anderson took us onto the athletic fields, into the classrooms, and gave us a front seat at graduations. I held the pictures of the Coleman High majorettes perhaps longer than I should have, but they were the perfect advertisement for the school. One of the pictures showed a majorette dressed all in white, wearing a tiara. Her legs were posed in a marching position and one arm was raised as if to signal the start of something good. Around her, the scruffy grass and cracked sidewalk left much to be desired, but Mr. Anderson's camera had focused on her bright smile, her tasseled white boots, and her carefully

coifed hair. The picture captured the best side of young black women, high-stepping and looking good in spite of the restrictions they often faced.

"In some ways, the precision marching and the majorettes became symbolic of the resilience that permeated Greenville; the band played on," I said.

The young woman's style, precision, and absolute beauty filled me with admiration, not only for Coleman High, but for all the other black bands, drum majors, and dancing majorettes who gave rhythm and music to our living. The pictures were turning out to be just as I had hoped — a country boy's dream proving true. I may have been sitting in New York City, but my mind was reeling back to the thrill of a Mississippi Delta homecoming game.

Mr. Anderson's camera also captured the thrill of socializing, of first dates and budding romances. He left us pictures of silk dresses, black tuxedos, and elaborate corsages. Everyone in Glen Allan knew about the upper-crust proms held in Greenville at Coleman High. I never went to one. I could only imagine what they were like. Now Mr. Anderson's pictures were my invitation to the Coleman High prom I never attended. As I held one picture in my hands, I felt as if at last I was there. The girl in the picture looked so beautiful in her white, off-the-shoulder, ankle-length, ruffled gown. She wore a smile big enough to welcome me and her date. Mr. Anderson's camera also captured her date's cocky look. He didn't smile. His eyes stared straight from history, telling me that he was The Man. He was in high cotton that night. Though there was no band in the picture, I could almost hear the music of the Delta inviting the couple to the dance floor, where they would "slow drag" the night away to the consternation of their parents. For this one night, the world was pure magic. The humiliations of segregation were on holiday.

NOTABLE PROFESSIONALS AND THEIR SOCIETIES

With such vivid pictures laid out in front of us, it was not difficult to imagine ourselves in the midst of Greenville's colored middle class. The women were graceful and beautiful; the men serious and protective.

"This looks just like a 1950s picture out of *Town and Country*," one of the women at the table said.

"And why shouldn't it?" I replied as she handed me the picture. "After all, these women were among the highly educated, worldly, and sophisticated."

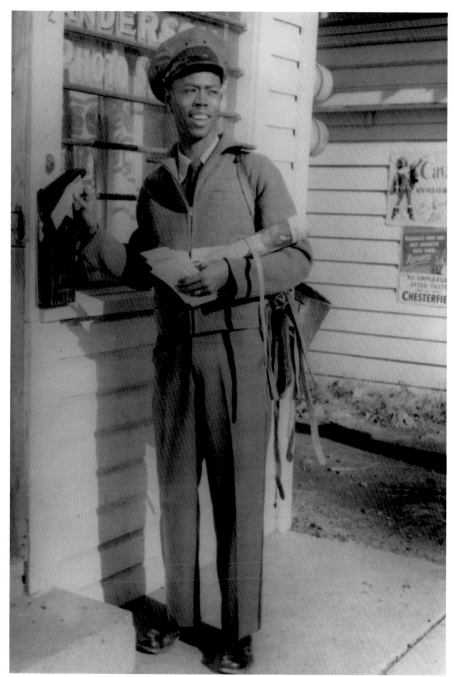

Mr. James McCullin, Nelson Street postman

The Greenville society ladies were posed on thick stuffed couches, their Coca-Cola-bottle shaped legs carefully positioned in a row. We all laughed as we imagined Mr. Anderson, the preacher/photographer, in the presence of such gorgeous colored women. No doubt he could have taken these pictures for days. Smooth satin on soft brown skin with silk stockings and diamond rings, this could have been a scene from Harlem, but it was not. It was the black sorority and club ladies of Greenville, Mississippi. These were the proud children of hard-working and forward-looking parents, grandparents, and great-grandparents. These were dreams come true — black people who had left the cotton fields and farms far behind, establishing stylish city lives, wearing lipstick and high heels and tailored dresses, all neatly pressed. These genteel folk were clearly proud of how far they had come and Mr. Anderson was there with his camera to make sure that their gracious living and good looks did not go unnoticed.

According to Shawn and even from what I had heard while growing up near Greenville, to have an Anderson photograph hanging in your parlor was the height of good taste. His appreciation and respect for his subjects was obvious; he captured his sitters at their very best. You dressed up to go to his studio and he made sure that your efforts did not go unrewarded.

The men were equally well dressed, looking every bit the part of the respected doctors and lawyers they were. These men would have been at home in the Cotton Club of Harlem or the great convention halls of Chicago. They had achieved academic and professional success in a world that questioned their intellectual capacity. And here they were, proudly posing in their spacious living rooms, wearing fine suits and wire-rimmed glasses, living proof of Dr. Carter G. Woodson's dream. Many of them had undoubtedly gotten their early start at Coleman High, risen through the South's black colleges and universities, ascended to the top of Greenville's society and stayed there.

Even the mailmen looked sharp. Mr. Anderson had taken many pictures of mailmen, who were important figures of Greenville's colored society. Mailmen crossed the borders, delivering letters in both the colored and white neighborhoods. In the white communities, they were simply colored postmen, but within the colored neighborhoods, they were men of stature. They were Federal workers with a pay scale better than most, and they looked the part. Always dressed in tip-top pressed uniforms with their hair neatly trimmed, they set the standard of excellence that had come to define Greenville's world. With an above-average income, their lifestyle and that of their children would make a difference in Greenville.

Though their schedules were demanding, they nevertheless took a moment to pose for Mr. Anderson. He caught their cocky smiles as they tipped their hats to the side, adding a bit of jazz to their uniformed world.

SULTRY, SASSY, AND ENCHANTING

As we continued to flip through the photos, it was as if Mr. Anderson himself was taking us by the hand, offering us a personal tour of the people who populated his world. He knew every back corner in the colored community and his camera was determined to show us everything. His photographs revealed the dignity of Greenville's colored middle class, but also its sultry, sassy side. Making their way to the top of the stack were photographs of shapely black women in tight-fitting bathing suits, posing for the camera, looking us right in the eyes. Maybe we were caught off-guard when the bathing beauties smiled up at us. Laughingly, I joked to the group around the conference table, "Bet you guys didn't know that we lounged around the pool."

Well the truth be told, these shots of Greenville's young bathing beauties were a discovery for me. There were no swimming pools in Glen Allan or in the neighboring cotton communities. These pictures took me to a leisure world that I had seen only in the pages of magazines. But it existed in nearby Greenville, where girls posed on lounge chairs by their pools. Some even posed on the street. One picture showed a lady in her form-fitting bathing suit standing in the middle of a gravel road, hands loose by her side. I could see the Johnson Grass, a southern menace, poking up around her ankles and her high-heeled shoes. (I was always told that you couldn't kill Johnson Grass, no matter what; it always grew back up. And sure enough, here were those nasty blades stubbornly sticking their way into New York City.) The sassiness of her stance caught our attention. Who was she? Was she a teacher? Was she visiting from up north? We'll never know, but it's safe to say that her coy pose caught the eye of the camera lens and treated us to a good look at fine living.

There, laid out on the table in front of us, were some of Greenville's most beautiful colored women, languorous smiles curling at their lips, daring us to take a closer look as the preacher's camera clicked away. Mr. Anderson snapped pictures of their softness and beauty, those captivating smiles that lit up ebony faces, those mysterious chocolate-brown

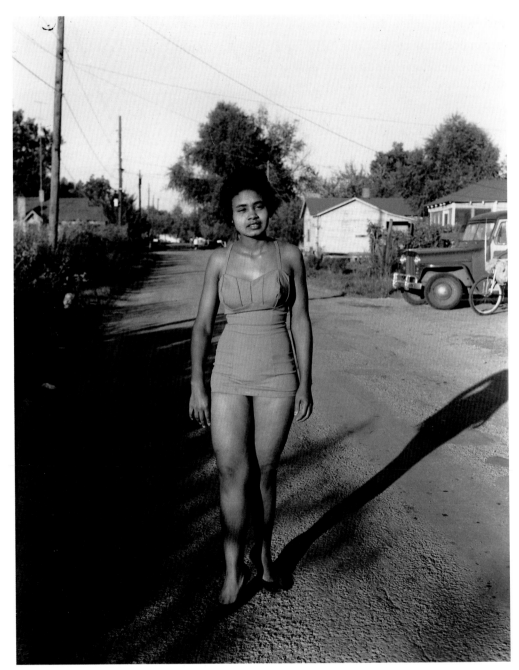

A bathing beauty

eyes that seemed to say, "Take your time and look slowly. I ain't going nowhere." Yes, the black women of the South were sassy and alluring and were in bountiful supply in Greenville. Mr. Anderson, that lucky preacher with a camera, captured what I missed "up the road" and what most others never saw.

Greenville women were proud of their looks. They even hosted beauty pageants. Here were pictures of black women wrapped in yards and yards of white taffeta, lace, and silk. In the middle of the Delta during the height of segregation, these ladies were holding full-fledged fashion shows. Mr. Anderson captured them with their heads held high and slightly tilted as they walked the narrow aisle between wooden folding chairs. The audience, which now included all of us around the table, was determined not to miss one swing of the hips. We followed the rustle of silk and taffeta as it glided down the aisle. These ladies were show-stoppers and Mr. Anderson's camera was poised in just the right place to catch their defiant glances that outwitted Jim Crow and his attempt to relegate them to second-class living. Not these ladies. No sir.

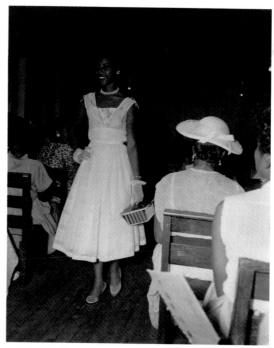

"Silk and taffeta gliding down the aisle"

GOOD LIVING DURING BAD TIMES

Of course, most ladies' finest hours were on their wedding days and it seemed that Mr. Anderson must have taken every wedding ever held in Greenville. There were dozens of them, featuring lace gowns, floral arrangements, and multitiered cakes. Here were the grandchildren of African slaves, celebrating life and the bonding of family in elaborate ceremonies. Legal segregation would not keep these couples from formalizing their love and relationships. They loved during the height of Jim Crow in Mississippi. Their elegant pictures gave no hint of the difficult times that dogged their lives. In one wedding photo, the groom and his best men are dressed in white jackets, flowers tucked into their lapels. The groom stands before an ornate altar, watching and waiting for the right time to say and hear, "I do." His eyes are focused on the bride, a picture of southern beauty in a ruffled white dress and sparkling jewels. Nothing is left out of the view of the lens, including elaborate flower arrangements and the look of love.

I watched as those sitting around the conference table took long looks at the wedding couples. We all had our favorites and found them difficult to let go. We kept gazing at them over and over again. The pictures reminded some of us of our own special days. But these people's pasts and futures were so different from our own. It made us wonder how in the world such good living could have happened during such bad times.

NELSON STREET

After the work of the day was done and the weekend descended, Greenville's couples would reemerge from their houses in a rather dapper style, suits and hats and smiles to match. These were the photographs that had caught the eye of young Shawn Wilson when he first discovered Anderson's archive. Today in New York City, generations removed from Anderson's photo shop, the pictures of these fancy dressed men and their glamorous wives took our breath away.

"This photograph is definitely Nelson Street," I said, leaning across the table and glancing up at Shawn. "When night came to Greenville, Nelson Street came alive." Maybe it was the way I said it, but my statement prompted a wave of questions from those present. "What is Nelson Street?" "Come on, why are you laughing?" "What was this street?"

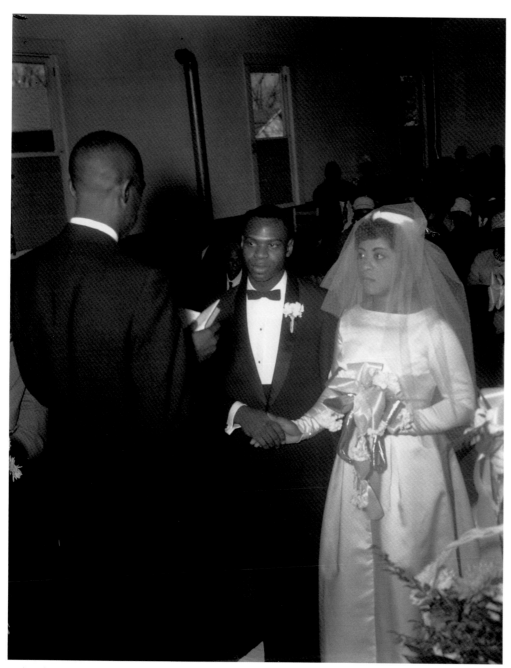

A church wedding

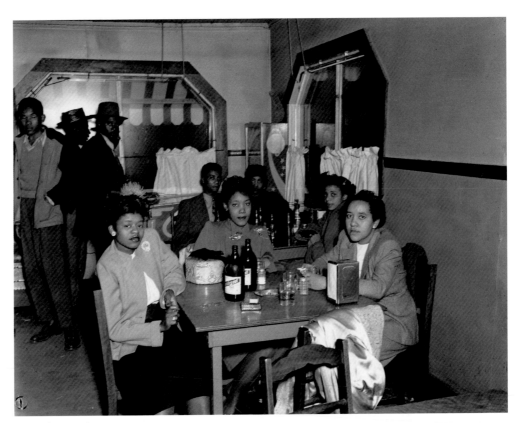

Nightlife on Nelson Street

"Clifton, should I tell them or do you want to tell them?" Shawn asked as he leaned back in his chair and smiled.

Even in New York City, forty years later, just thinking about Nelson Street could make you laugh out loud with pleasure, wishing that you could still be there at about 10 P.M. on one of those hot, sultry Saturday nights. During the era of legal segregation, nearly every major southern city or town had its own version of Nelson Street. It was the colored business district by day and dreamland by night. Greenville was no exception. During Mr. Anderson's time, black businesses lined both sides of Nelson Street, which was anchored by large brick churches and tall trees. The merchants of Nelson Street ranged from dry cleaners to meat markets to beauty parlors to clothing shops. Their proprietors formed the base of Greenville's colored middle class. These were the patrons of H. C. Anderson. He captured their entrepreneurial spirit each time he said, "Hold it right there. You're looking good."

Nelson Street became the colored community's business street after the crash of 1933. During the late 1800s and early 1900s, Washington Avenue, the main white business street also had a respectable number of black businesses. But as Jim Crow grew more entrenched, Nelson Street became the home to black entrepreneurs, housing both their daytime businesses and their nighttime bars and clubs. By day it was a small, respectable business district; by night it became an intoxicating dreamland, infused with the sound and the smell of the blues.

I was sensing the New Yorkers all wanted me to tell them more about this magical street that caused overworked and poorly paid black folk to dress up and lay their burdens down. I had to explain that I knew very little about the actual happenings on Nelson due to my strict upbringing. The Nelson Street nightlife was a world that the church had actively sought to keep us from. My great-aunt Ma Ponk who raised me was equally determined that I would know as little as possible about what really went on in Greenville after dark. But my mother had five older brothers, the Chaney boys, who were free with tales of their late-night escapades. Uncle Zee and Uncle Mack told me everything and I gulped it in with wide-eyed anticipation. They were handsome men and the women knew it. Sometimes, when they returned from their dates, they would sit on the front porch and relive every single minute detail by detail. They told me about women in dresses too tight to walk in and women ready to dance closer than silk. The more they talked, the more I ached to see this night-world for myself, but I never did — that is until now. Anderson's pictures of Nelson Street nightlife brought those front-porch conversations to life. Uncle Zee and Uncle Mack were right. It

was all they said it was. Fortunately for us, Mr. Anderson paid our cover charge and invited us to sit in.

As we gazed at the pictures I laughingly said, "I often overheard conversation that I should not have heard." Now I realize that I had missed part of my education. Anderson's Nelson Street pictures were making Greenville even more magic for me, who grew up dreaming of the bustling, glamorous city just a short distance down the road. I remembered hearing how the doors to the shops would lock up in the evening and the doors of the clubs and juke joints would fly open. The streets would be filled with different sounds — laughing couples, tinkling glasses, the slow, muffled beat of a bass guitar. Long cars, decked out in chrome, parallel parked in the street, their engines humming, young men giving cat-calls from their windows as well-endowed women strolled in and out of their view, their heels clicking down the sidewalk. Also swelling Nelson Street were well-dressed professional men and women, wooed by the wailing sound of the blues and the humidity of the evenings. Legal segregation barred them from the white-only clubs with their manicured lawns and swirling Louisiana fans. Their choices for entertainment were limited. But Nelson Street would fit their bill.

Mr. Anderson walked us right into the back rooms of the hottest black clubs. Here was a whole world within a world. For the very first time, I could look into the faces of the dancing couples swaying to the music as the camera followed their smooth moves. I could tell from the photographs that the moves were smooth, the type that makes onlookers envious. And here the camera invited us to join a crowded table for eight. Anderson caught freshly pressed hair glistening under the glow of exposed lightbulbs. Animated faces laughed and chattered late into Saturday night as Nelson Street drowned out the unpleasant reality of Jim Crow. Lost in the sounds of the guitar and the wailing of the blues, the blacks of Greenville created their own version of Harlem's Cotton Club.

Here at last was Nelson Street on Saturday night. I thanked Mr. Anderson for getting me inside Greenville's juke joints without Ma Ponk catching me.

THEN CAME SUNDAY MORNING

Saturday night led to Sunday morning and Mr. Anderson followed Greenville's black citizens to the wellspring of their strength, the church. Just as his pictures of beautiful women,

handsome men, and smiling babies had given us insight into their work and leisure, the pictures of their church life revealed the deep source of their faith and hope.

The role of the church in the everyday lives of southern blacks has been well documented. Even the on-the-run photojournalist could not ignore its influence. Their pictures, published in *Look*, *Life*, and the *Saturday Evening Post*, often included the powerful black ministers, who helped them as they tried to document the black struggle for justice. But while they featured the ministers, the journalists often overlooked the lives of the parishioners. They were so focused on the plight of the poor and on the injustices of our society that they largely ignoring the world of civility and spirituality. For them, the rundown shotgun houses were more print-worthy that the church suppers or the religious auxiliaries that thrived in Greenville. They caught the perspiring preachers in action, but they missed the men on the deacon board. Mr. Anderson did not. He and his camera took us to the very heart of the black community, the places of their faith.

As we slowly left Nelson Street, I reminded those at the conference table that the church, the independent arm of black life, was and still remains an integral part of southern living. No one was surprised at the number of clergy and church-related photographs. After all, Anderson was a Baptist preacher. But I think they were surprised by the power of those photographs to pull us into the setting as if we were members of the congregation. Here we were in New York City about ready to have revival in Greenville. The pictures invited us all to join in. Reverend Anderson wanted us up front in the first pew.

Mr. Anderson, who was himself a preacher, took many portraits of the African American ministers who held the community of a disenfranchised people together. Today, the conference table was covered with scores of such photographs — shots of stoic black preachers, dressed in their Sunday suits, looking firmly into the camera while holding the Bible in plain view.

In the midst of the stack of preachers was a photograph of the much-loved Reverend Savage. I didn't know Reverend Savage personally, but I had heard of him all my growing up days. I had been raised in Poppa's house, Reverend Joe Young of Glen Allan. Although Poppa was not a city preacher, he had friends among them. My mother, who grew up in Poppa's house during the height of his preaching career, knew many of these Greenville clergymen as they would often stop and visit Poppa. Reverend Savage was the one I heard her mention most frequently. He was a "big preacher." I was really too young at the time to fully grasp all that went into such a label. But as I grew older, I understood that a big

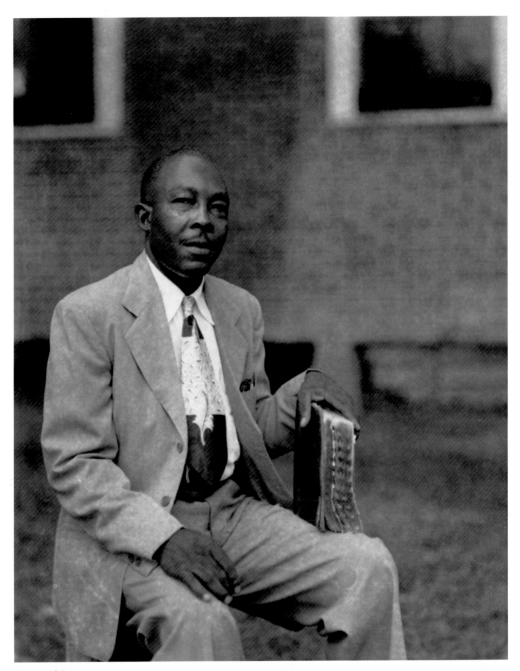

Reverend Savage

preacher usually had a brick church, a parsonage, a higher education, and a salary to match. And of course, the preacher could preach; he could dramatically and eloquently hold his congregation in the palms of his sweaty hands as his athletic body lifted the parishioners to a higher plane. He had the calling.

As I looked over the photographs of these black preachers, I remembered their passionate words, their stories that kept our hope alive. Their sermons were not just for the Sunday moment; they also spoke to the hurt and discrimination that we would face on Monday mornings. Though many of the preachers I knew were uneducated, they crafted words of encouragement and hope that left all of us with a better picture of ourselves. In some ways, that was what Mr. Anderson was doing, too. He caught these preachers at their best: dignified and defiant in the face of a world that sought to relegate their flock to an inferior position in an unjust, segregated world. As I looked at their pictures, I quietly thought to myself, "I am glad they were there." These men were the connective links to a sure world of equality and peace, a world just a hymn and a breath away.

Gazing down at the church portraits, I knew, as did Shawn, that there was a much bigger story behind each picture. The black churches of Greenville defied the stereotype of colored people as lazy and undisciplined people. The black church had a rigid structure with strict lines of authority. Roles and responsibilities stood firmly in place, and Mr. Anderson had left pictures to prove it. He documented armies of church leaders in stiff suits with serious faces. He photographed scores of church auxiliaries all uniformed in their Sunday best. His pictures show the church as a sophisticated organization, one that resembles a major corporation with a CEO, the black preacher, at the top, and a "board," the auxiliary, in supportive, managerial positions. One photo depicted thirteen gloved ladies and regal men in double-breasted suits standing and seated on wooden benches in an old-frame building. These church elders were truly the salt of the earth. As I looked into their quiet, composed faces, I tried to imagine who among them were the teachers and who were the maids. Which one coached high school basketball and which one ran the elevator in the downtown department store? It was impossible to know. The church made them all equals, valued and productive citizens who worked to uphold the community.

In many instances, the church was where leadership skills were honed and practiced. It was where men of all ages gathered into brotherhoods, male groups in charge of the weighty matters of faith and destiny. Also called "deacon boards," these brotherhoods were run like small businesses with a senior deacon serving as the church's chief operating

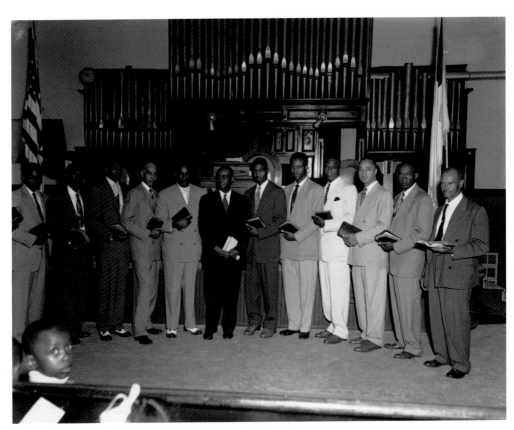

Mount Horeb Baptist Church

officer, ensuring that the will of the pastor was carried out. His position was one of pride and authority. He and his finance committee, which often included women, worked to keep the church solvent, making sure that the treasury was growing and monies would be available when the time came to build or buy a bigger church. During the week, the senior deacon may have been a handyman, teacher, elevator operator, short order cook, or field worker, but on Sunday, he was "somebody."

One photograph depicted just such a group. It was a picture of well-dressed men standing in a semicircle in front of the altar. At first glance, they may have been mistaken for members of the men's chorale. But I had seen that stance before; they were clearly members of the brotherhood. Mr. Anderson had captured their quiet, strong presence. He showed who they really were — men of strong moral character — rather than what society had deemed them to be — simple colored folk.

As I studied the picture of the men framed by the pipes of a grand organ, I noticed the face of a little black boy in the corner of the front pew. He had turned his head just in time to catch the camera's eye. There in Anderson's photograph were the present and the future, the old and the young bound together in one place, the church. As I looked at the boy, I wondered to myself if he realized the importance of the assembled men in front of him. These church leaders were who he could become, respected and valued members of the community. In spite of the harshness of southern life outside the church walls, this little boy was raised with hope. He was being raised in a place where men could become their best. Within the world of the church, men's jobs, roles, and responsibilities could lift them above their menial Monday through Friday living. The indignities they suffered in their daily lives would have no part in Anderson's Sunday photo session.

I knew these church groups well. Their counterparts also existed in the small cotton communities like Glen Allan. When rural black folk moved "up north" to Greenville, the church auxiliaries were the one thing they held on to. For many black farm workers with dreams beyond the fields of the delta, Greenville was their first stop on their way to a better life. Leaving their small shotgun houses behind, they would pack their meager belongings and head up old Highway One to Greenville where they would look for better housing and find better jobs. They abandoned much of their former lives on the cotton turn-roads, but not their faith. This treasure was all theirs and would be welcomed in their new city life. Thus, they took with them the best of the home community, while now joining other relatives and friends in pursuit of the pleasures of a middle-class, urban life. They stayed in

touch with their hometowns through sisterhoods and brotherhoods, the organizations that helped defray expensive funeral costs. These "works," as they were called, were often the only strings that kept new city people connected to the rural world they had left behind.

My cousin Saul was one such new arrival to Greenville. He lived on First Street just off Number One Highway, one of the prized neighborhoods for working blacks on their way to becoming middle class. The south end was not the nicest neighborhood, but it sure was better than the plantation life that many had left behind. And it served as a starting place. As their lives got better, blacks moved eastward. First Street was smack in the middle of that migration.

Saul was Greenville to us in Glen Allan. Often after their Sunday service at New Hope Baptist Church, he and his wife, my cousin Corrine, would drive to Glen Allan in their shiny 1958 Chevrolet. They spoke of their church involvement with every other breath. Their lives were defined by their church activity. Now that I think about it, I never knew where Cousin Saul worked. All I really knew about him was his role as a deacon in his church. That was his real pride and joy. That was where he dressed up and had people reporting to him. That was the place where his skills were recognized and appreciated. That was the place where the young men envied his position. At his church he was never called "boy." He was Deacon Peters.

I'M GOING HOME ON THE MORNING TRAIN

Mr. Anderson had quietly drawn us into the daily lives of Greenville's colored citizens. His old photographs had brought elegant Greenville to life. Though I only knew a few of his sitters by name and the others at the table knew none of them at all, Mr. Anderson had made the people in his pictures our own. We had grown close to them. We had inspected their faces. We had scrutinized the insides of their homes. Then, in the midst of the photographs of babies, basketball players, majorettes, and preachers were a stack of photographs that chilled our hearts.

It had been a long time since I had seen funeral pictures. And here were dozens of them, stacks of pictures of open caskets and weeping widows. Death in the colored communities of the South was a public event, an extension of our living. As the pictures of funerals were passed around the table, I could not help but recall my personal memories of people I'd loved and lost, leaving for a world I was too young to understand.

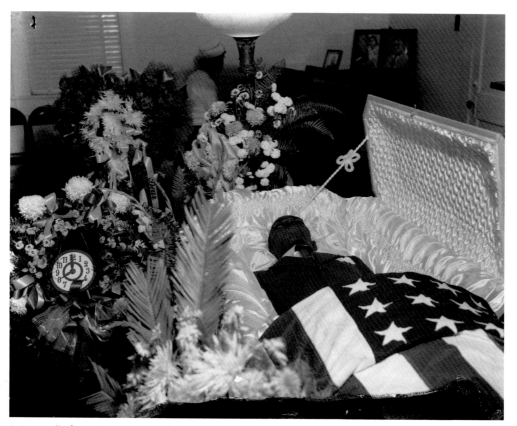

A Greenville funeral

As I held one of Mr. Anderson's funeral pictures between my fingers, I could not help but recall the death of my grandmother and the role the Greenville funeral home had played in her funeral. I was very young, maybe in the second or third grade, when my grandmother Rosie Peters Chaney passed away. I remember her long black hearse followed by a line of long black limos. Wailing music emanated from the hearse. It was like New Orleans, where jazz bands and singers often process in front of the hearse as the last good-byes are given. I can still hear that melodious mingling of piano and drums as the hearse drove into Glen Allan from Greenville. This was the sound that Mama Pearl and Poppa Joe had requested to alert the town that Grandma Rosie's body was on the way. The funeral home directors in their pressed black suits and white gloves boomed out orders, leading us into Saint Mark's Baptist Church, the small church that I had known all my life. Dillon Funeral Home had prepared my grandmother's body. Grandmother Rosie had been a beautiful lady with long black hair and a clear, smooth complexion. In her casket she did not look sad, just asleep, and she was dressed as if she would be up the following tomorrow, early as always.

In Greenville and throughout the South, a great deal of value was placed on dying "well." It may seem rather odd that people whose lives were full of struggle celebrated death with such elaborate testimonies to their living. I suppose they wanted to be remembered not as they were defined by the white community, but as they saw themselves and as they lived their lives within their own black community. Mr. Anderson's pictures validated this effort. He shows family and friends standing around flower-draped caskets. They seem to be saying, "Yes, we are the descendants of the Africans who became slaves in America. We have been overlooked and dogged by legal segregation. We have not been given our rightful places at the table of humanity. But we are family. We have stayed together. We have dreamed, raised our children, and contributed to our community and now we say good-bye, our dignity intact." Blacks were not ashamed to die. They wanted to go out in high style.

The camera played a crucial role in recording those final moments when relatives and friends said good-bye to those with whom they had shared their lives. Mr. Anderson positioned his camera up front near the casket, following the instructions of the family to make sure the best shots were taken. Careful not to get in the way of the ushers and the mourners, Mr. Anderson delicately made his way close enough to get a coveted facial shot of the departed. The camera was a welcomed part of the ceremony. Mr. Anderson's presence

assured those present that their family member deserved the best. The elegant exit of their loved one, captured forever by the magic of photography, would be the final bow to his or her triumphant living.

The funeral home operators formed part of the backbone of the southern black middle class. Segregation extended to the grave, offering these businessmen a handsome market share of business. From their constant and predictable flow of income, they could build nice homes, send their children to private Catholic schools, and put away money to be inherited. Many undertakers became quite wealthy. They had gracious homes filled with antique furniture, new cars, classy clothes, and sparkling diamonds. Much of the money came from the small towns of the segregated South. When I was growing up in Glen Allan, everyone who died went through the skilled hands of a Greenville undertaker. And every bereaved family visit to the black funeral homes left dollars behind, which lifted the undertakers into positions of prominence within the colored communities. Longevity of service, name recognition, and quality of work marked their status within those communities. In Greenville, Dillon, Huddleston, and Edward and Evans funeral houses dominated the colored market for decades. As I recall, to be funeralized by the Dillon family was the height of departure; thus my great-grandparents' choice when my grandmother Rosie died. The Dillons were known for their professional service, which was costly but delivered in style. Dillon Funeral Home would put you away nicely.

PICTURES THAT CHANGED THE SOUTH

The 1950s would usher in a new era, an era in which the protective middle-class walls built by both blacks and whites during legal segregation would slowly start to crumble. Various leaders within the African American community began to look beyond Greenville's comfortable enclave to the lives of rural blacks who were being left behind, emotionally, intellectually, financially, and physically. They saw hunger. They saw illiteracy and ignorance. They saw fear. They protested and finally received help from the federal government in the form of federal community block grants. These funds went to food and educational programs. Many of Mr. Anderson's patrons were involved in this movement and they invited his camera to document their efforts.

I had left the Delta before the Civil Rights movement started, and I really did not expect to see any people I knew amongst Mr. Anderson's photographs. But then I spotted one of my grade-school classmates. It was Frank Hudson. He was standing proud with members of Head Start. I had been told of Frank's involvement with the educational movement, and I was thrilled to find that Mr. Anderson had validated his role in improving the life of blacks in the South.

My own mother had also been part of Head Start, helping to teach the children of share-croppers, many of whom lived just outside of Greenville. Head Start was the gentle side of the movement for change that was taking place in towns like Greenville throughout the South. Mr. Anderson was there in the thick of it all, just as he had been in their homes, their churches, businesses, and schools, recording a movement that was slowly gaining momentum and that would eventually erupt into violence and death.

In the 1950s, black people began marching, protesting, and registering to vote. Mr. Anderson, his camera, and tripod captured the close-ups of anxious faces, hopeful youth, and even the frozen bodies of those whose lives had been riddled away by bullets in the night. *Ebony* and *Jet*, major black publications, hired Mr. Anderson to get the photographs of the burgeoning social movement. Of course, the Civil Rights battles also drew photographers from the North, suddenly desperate to give the world their dramatic view of the South; but only Mr. Anderson, Greenville's own photographer-in-residence, could capture the everyday struggles that fueled the black community's commitment to the movement for change.

Black people helped each other by providing hot meals and an early start in education to the less fortunate. They held hands with the federal government and remained committed to earning the right to vote. Many of the white citizens of the South would see this social and political movement as an assault upon their own way of living. Under the guise of lead-ership, some of the members of the white citizens' councils became instruments of destruction, violence, and even murder. Mr. Anderson's camera documented their activities. And now we were holding pictures of that dark time in history.

We were all quiet at the table as a murdered Civil Rights worker stared up at us. I held the picture of the bloated face, the eyes too damaged to close and the look of terror frozen in time. The photograph brought back a rush of feelings — the reality of a movement that I had witnessed from afar. The photograph shook me in ways I had not imagined. For a few short moments, I felt the shock of adrenaline that comes with violence; the taste of fear; the

seething, deep-rooted hurt that so easily turns into burning rage. These were the feelings that erupted throughout many of the cities of the South.

Everyone at the table was quiet. For most of the morning, we had laughed and chattered over our discoveries. It was easy to look at smiling babies and pretty women and handsome men all dolled up. We could join them in their dancing and worship in their churches. But these violent images jarred us. They underscored the color line.

I passed one photograph of a corpse around the room. It was Reverend G. W. Lee, a Civil Rights activist and preacher who was murdered on the night of May 7, 1955. Though this riveting picture of a violent death was from half a century ago, it looked like Mr. Anderson had taken it yesterday. It was shot up close, leaving nothing to the imagination. So vivid was the image, you could almost feel the pleats in the satin that surrounded the corpse.

The group around the table hardly knew what to say. At this moment, intellectual chitchat would not do. After all, what could we say to change the reality of Reverend Lee's life and death? We were looking at a picture of a man murdered for defending democracy. Reverend Lee just wanted decency. Was that too much to ask?

The next pictures gave us an inside look at how Lee's murder impacted the community. One photograph was very outspoken; it was a picture of accusation. An old black lady stood and pointed to the place where the shots that killed Lee had been fired. You could almost hear her saying, "Dis is whar it all happen. I heard the shots. I saw the blood. This is where he drawed his last breath."

Other pictures brought us to Reverend Lee's funeral services. We peered into the tear-stained faces as hundreds of blacks sat somber and sad, bidding good-bye to their family father, their leader who had lost his life to the cause.

Each Anderson photograph told a story — stories of dreamers and a hopeful people who had carved out a middle-class living in the midst of the harshness of legal segregation; stories of violent tragedies and death. For many Americans, the battles of the 1960s would be the only images they would have of Mississippi and her black people. Traveling photojournalists made sure that the sights and sounds of the Civil Rights movement would be forever etched into our collective memory and rightly so. But for those of us who lived in the South when the curtains of separatism divided our worlds, we also knew of another, quieter place where the children of the Africans who had been slaves built houses and communities for themselves and their offspring. Their fine living reflected their proud and hopeful dreams

for their children. Thanks to Mr. Anderson, their courageous and gracious everyday lives would not go unknown. His camera and his eyes left us proof of their fine living as well as their ongoing plight and struggle.

STAND UP NOW AND SMILE, WE GOT ONE MORE SHOT

There was little doubt left in our minds: The Anderson pictures told the stories of a people, place, and time in American history that we all needed to know, revisit, and share with others. In New York City, the forgotten world of Greenville, Mississippi, had come alive for all of us as Reverend H. C. Anderson took us on his personal tour. He took us into corners and rooms that we never would have seen. He slipped a nickel into the silent jukeboxes, drawing us into the dancing of lovers. He invited us into a society of good-living, upstanding colored people. We were overwhelmed, as if we had just heard a most powerful sermon.

I also felt as if Mr. Anderson was stretching our vision beyond the Delta, beyond Greenville. He was nudging us to explore the hundreds of other "Greenvilles," forgotten towns just off America's main roads. His pictures were urging us on, saying, "There's more. There are other stories. There are more pictures in more trunks than you can imagine."

As I looked at the stack of black-and-white photographs, all piled high in front of me, I remembered lazy Sunday-afternoon conversations about other communities like Greenville, growing in the shadows of a bustling America. These thriving colored communities were not included in the chamber of commerce brochures. They were quiet towns that emerged from the ashes of slavery and reconstruction. Freed blacks had worked hard to create their own safe havens. And for a season, those havens prospered. Even the ravages of legal segregation couldn't hold them back. Time, the restrictive Jim Crow laws, and the introduction of legal segregation, caused them to slowly disappear and with them, much of the memory of their existence. Now they are no more than the tired memories of a dying generation. Young black Americans don't even know such graceful, proud, prosperous living existed throughout the South.

But now we have the evidence. It was sitting there, on the table in front of me. I wondered: Maybe Mr. Anderson was hoping to save those dying memories. Maybe, by enticing young Shawn Wilson into his studio, he hoped to salvage a forgotten corner of history. Those

old folk from the South, they had their ways about them. They knew how to look ahead. When Mr. Anderson showed Shawn his pictures, he brought the world into his studio.

I felt a sense of pride after sitting for hours listening to the soft rain on the roofs of Manhattan while sifting through hundreds of Anderson's photographs, all wonderfully preserved. I had taken in every word, listened closely as Anderson's images evoked heartfelt conversations of discovery and validation, surprise and hurt. The morning in New York City had educated all of us. And now we felt fortunate to have become part of the team that would expose this neglected corner of American life. It was as if Mr. Anderson was there with us, overseeing the project, reminding us to handle the photographs with care and to hold them by the edge and not to smudge the fine print that he had left for our viewing. I felt as if he wanted us to spend more time on some images than others as only he knew the effort expended to get that pose just right and to elicit the smile that wouldn't fade.

I felt confident that PublicAffairs would handle this project with dignity and that the works of Mr. H. C. Anderson would be treated with the respect due to any artist, who had captured the lives of a progressive people. I had watched closely as the pictures of people and places I knew became of value to others who had known little of that world. Anderson's photographs had been handled as if they were precious pieces in the New York Museum of Modern Art. The pictures were in good hands and good hearts. I could hardly wait to see them laid out for all the world to witness.

I had come to New York unsure if I would see the same Greenville I had gazed at from the front seat of Poppa's car nearly forty years ago. Based on the excitement of a man I had never met, Shawn Wilson, and his dream for pictures I had never seen, I had agreed to make this journey. Thanks to Mr. Anderson it had been worth it. I had reexperienced the Greenville I had known as a child. It really was as I had remembered it.

After saying good-bye, I took a cab to the airport and headed home knowing that Mr. Anderson's Greenville would become more than faded pictures from a forgotten past and more than personal mementos scattered across private mantels in Mississippi. I chuckled to myself as I imagined Mr. Anderson's voice to young Shawn Wilson, "You figured right, boy. There were some mighty big colored people in Greenville. And me and the camera was there in the midst of it all, the triumph and the struggle, just right around the corner."

THE PHOTOGRAPHS

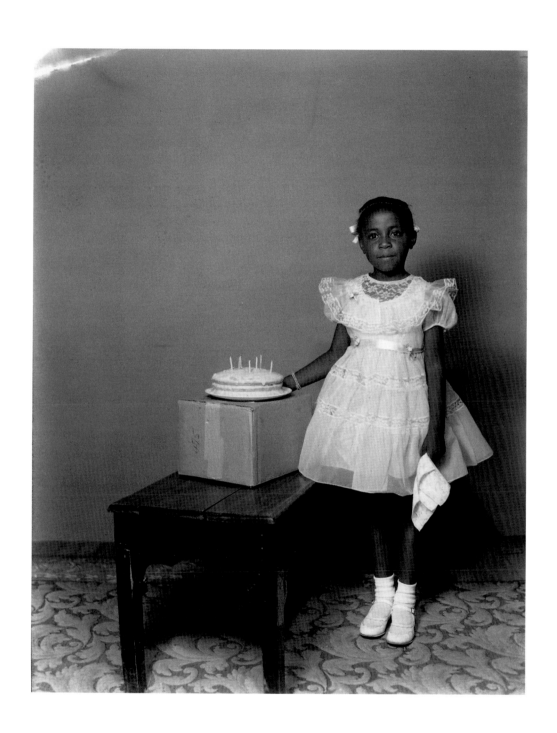

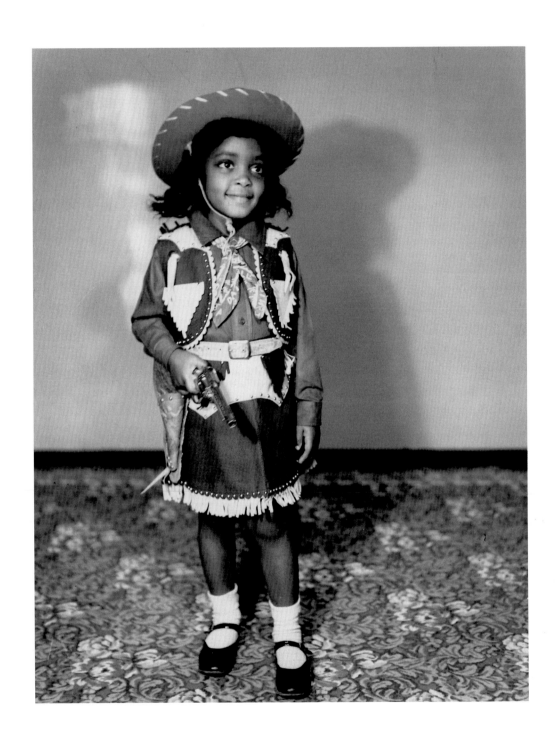

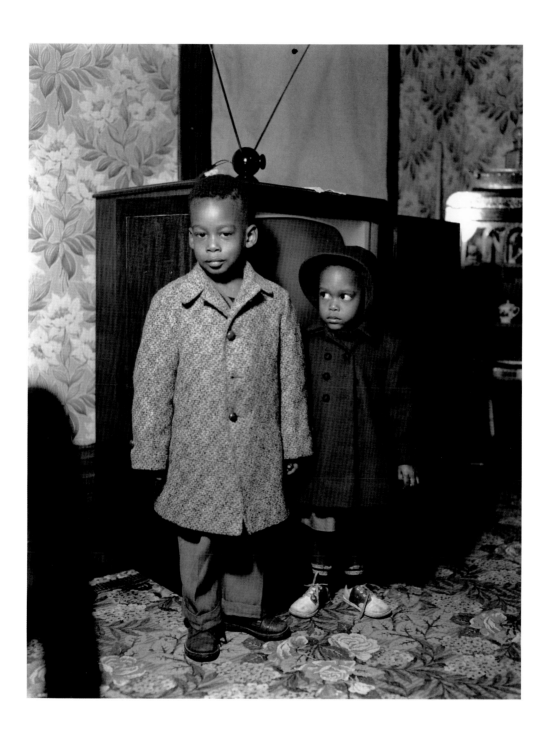

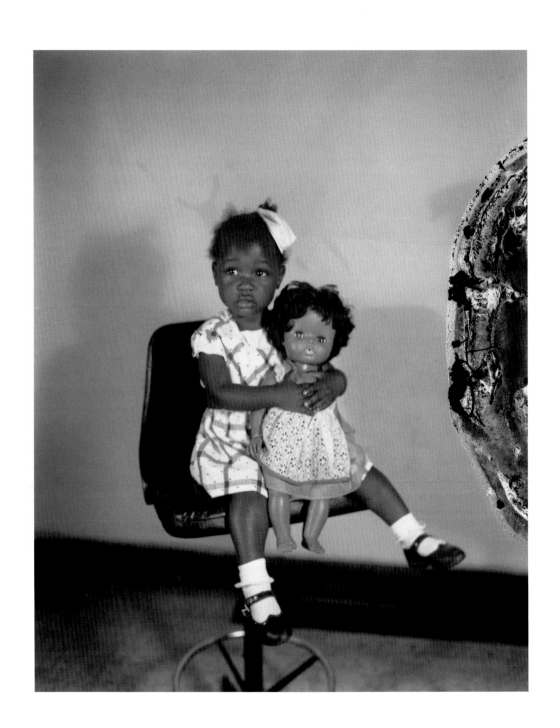

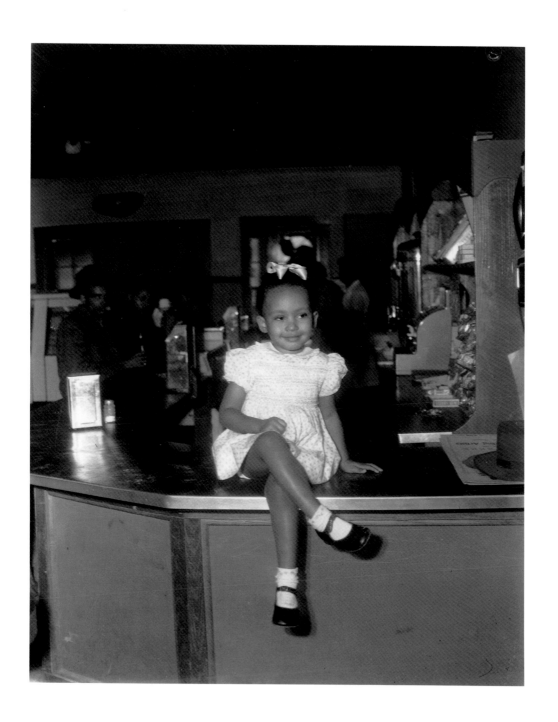

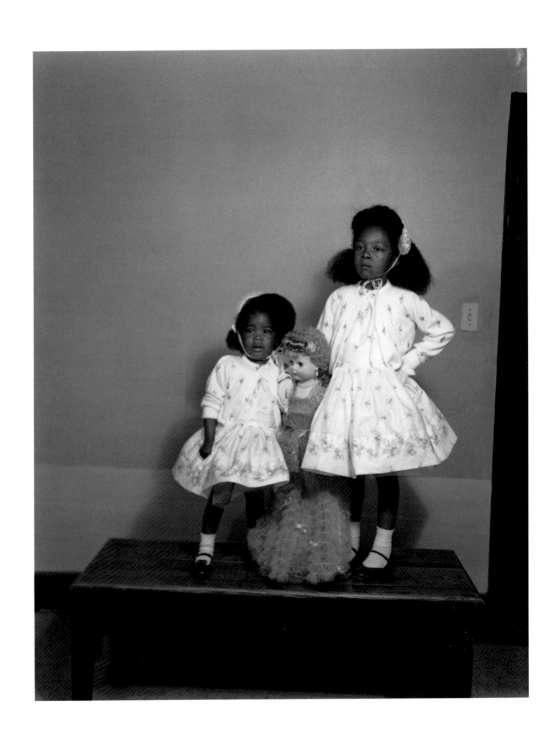

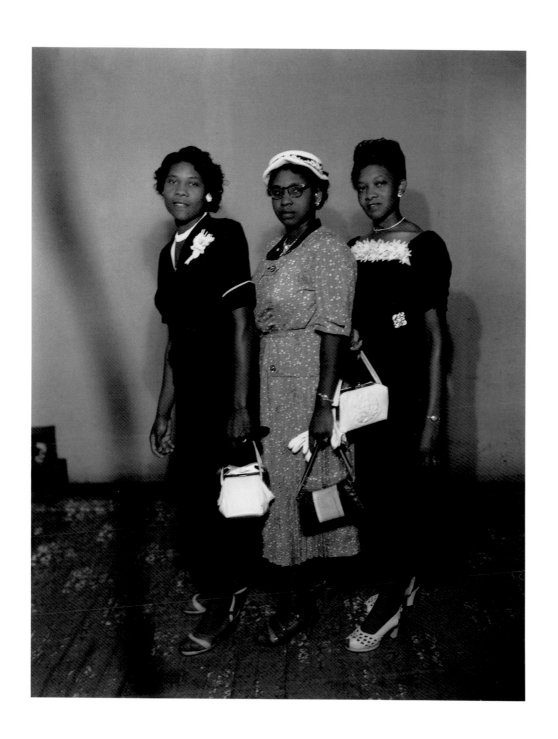

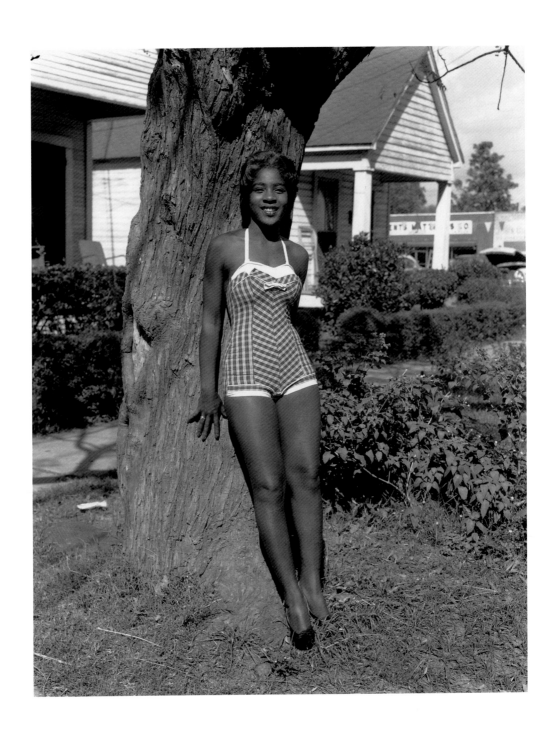

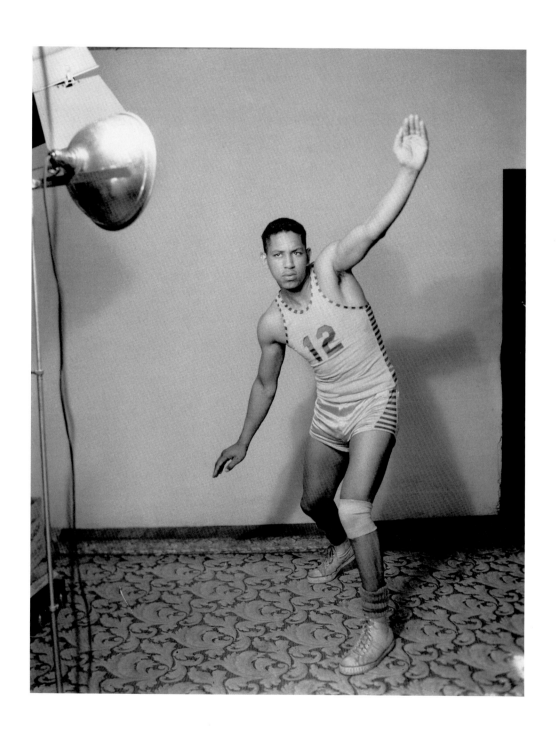

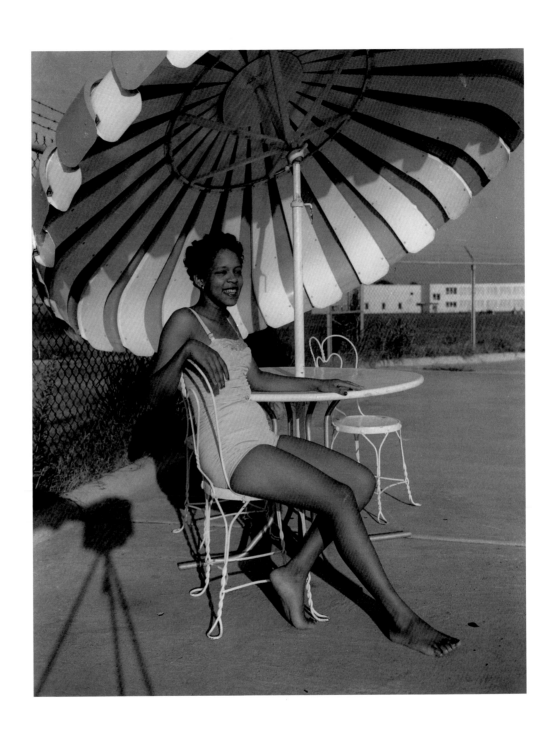

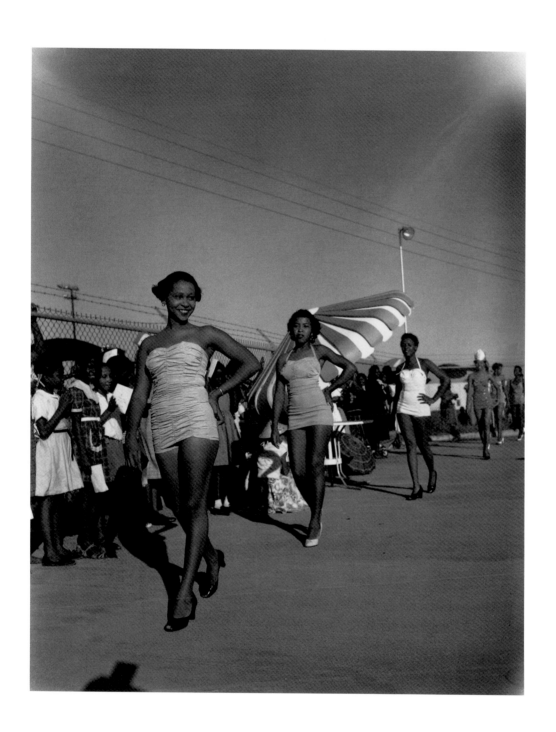

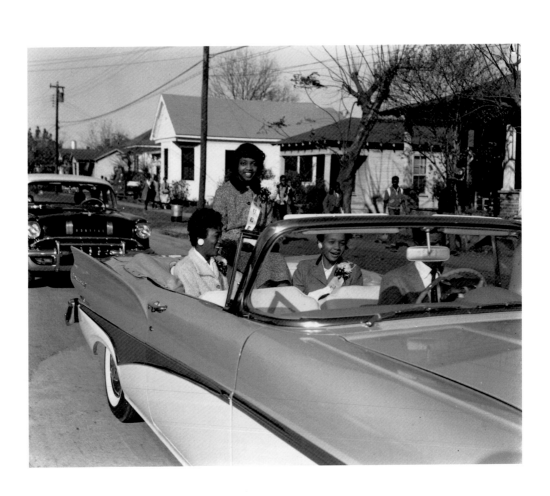

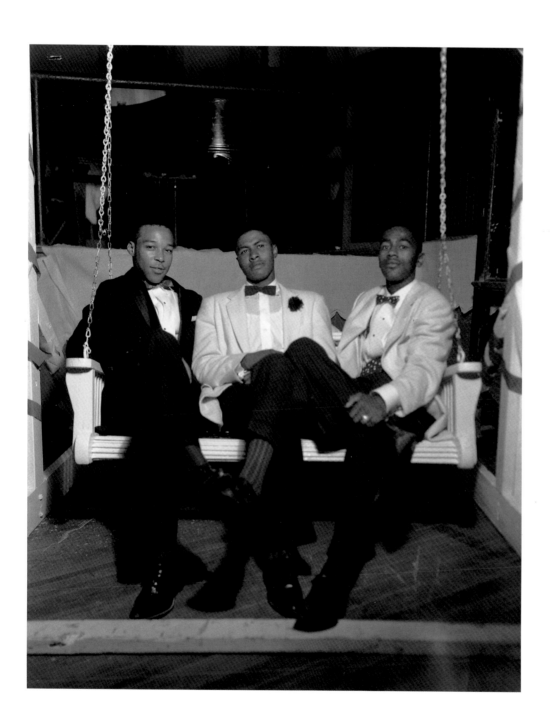

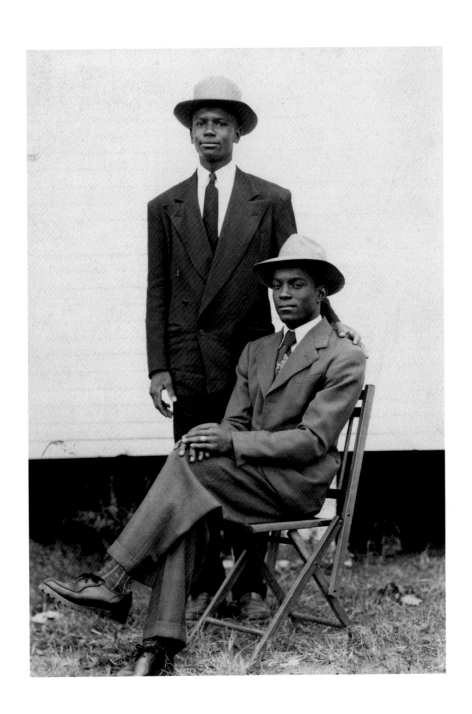

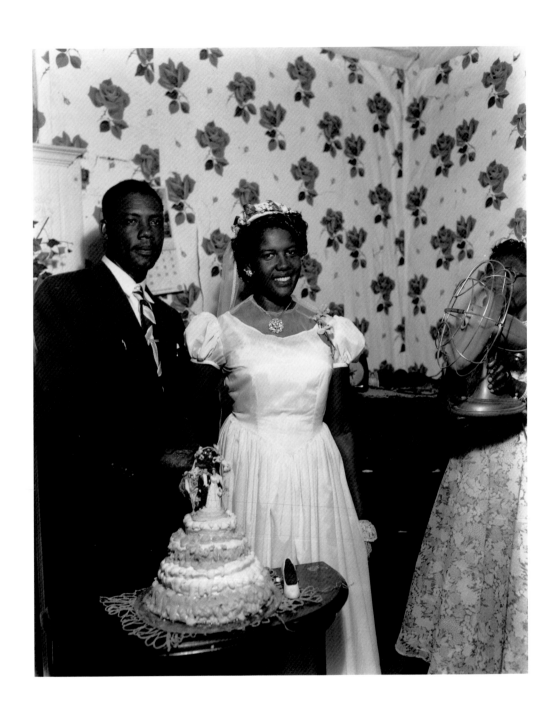

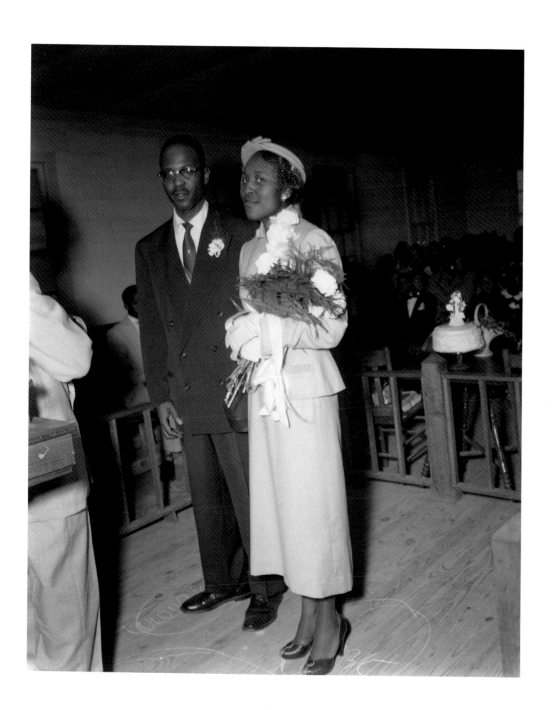

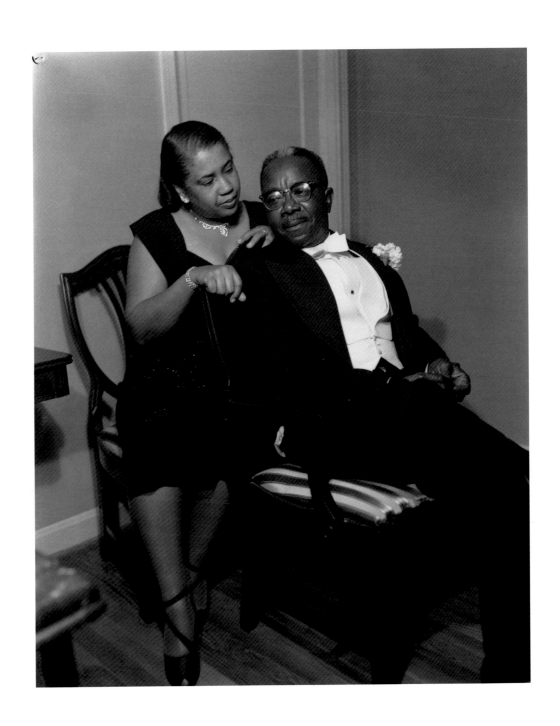

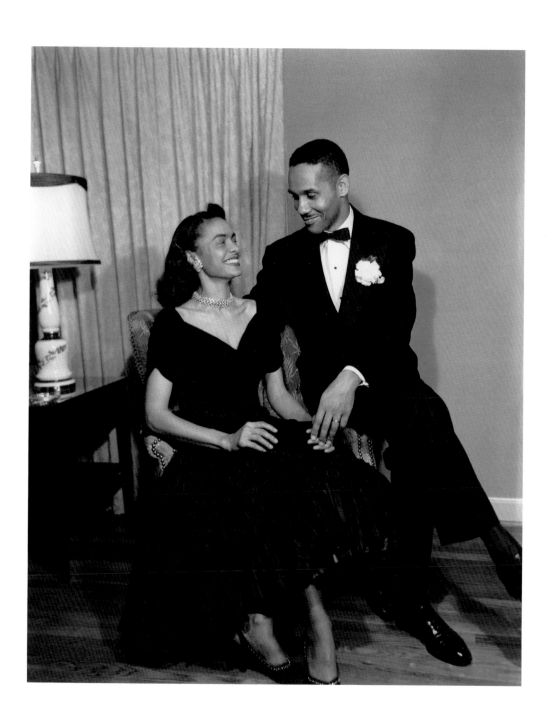

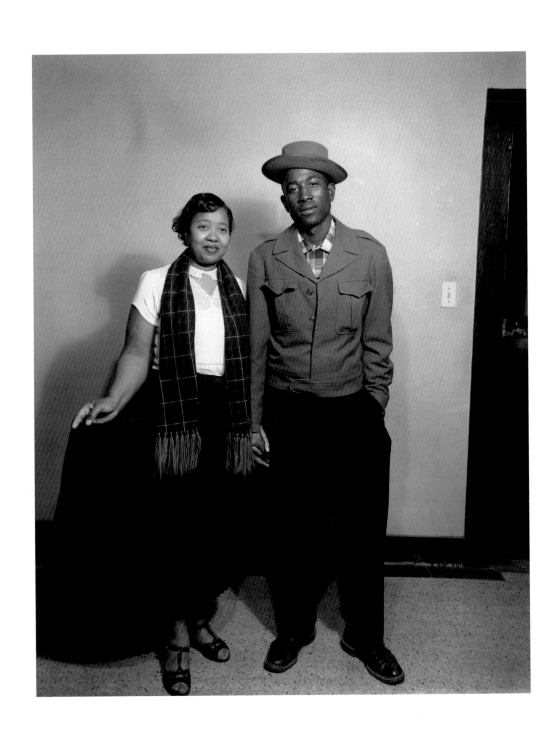

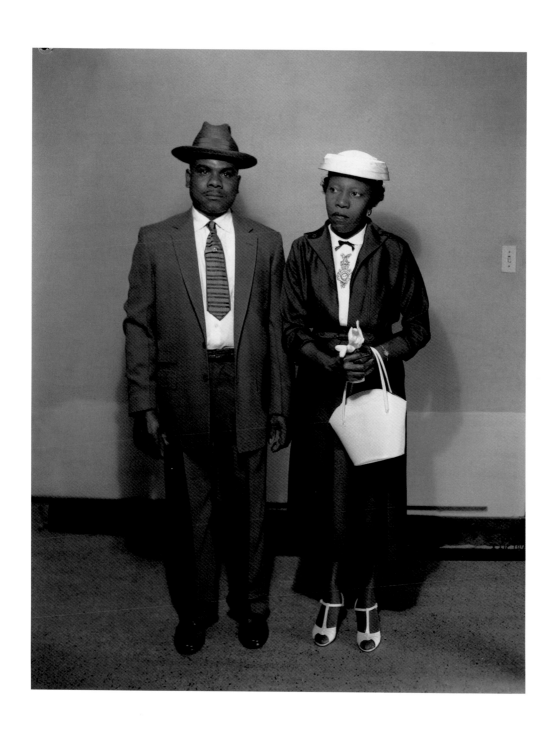

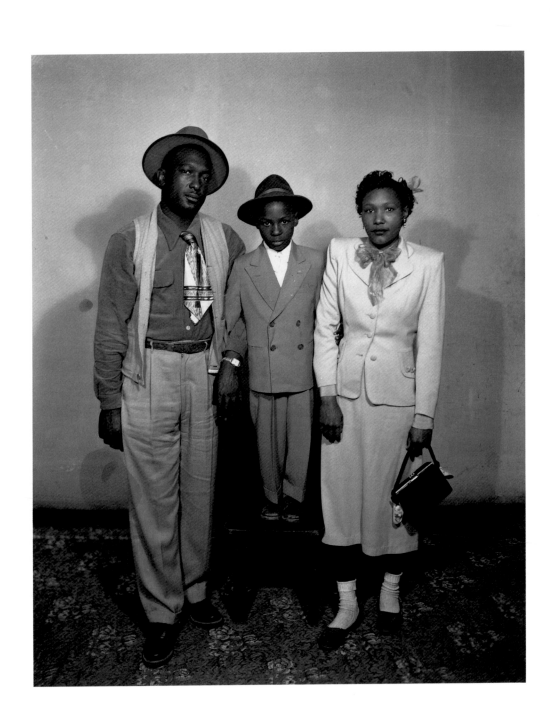

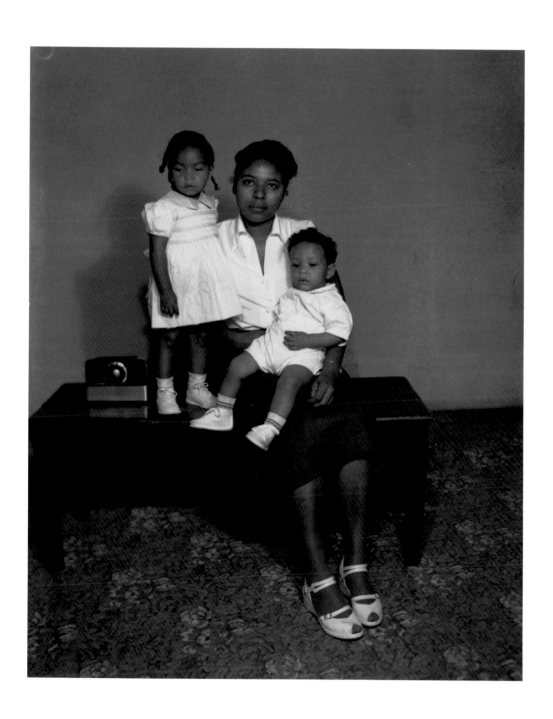

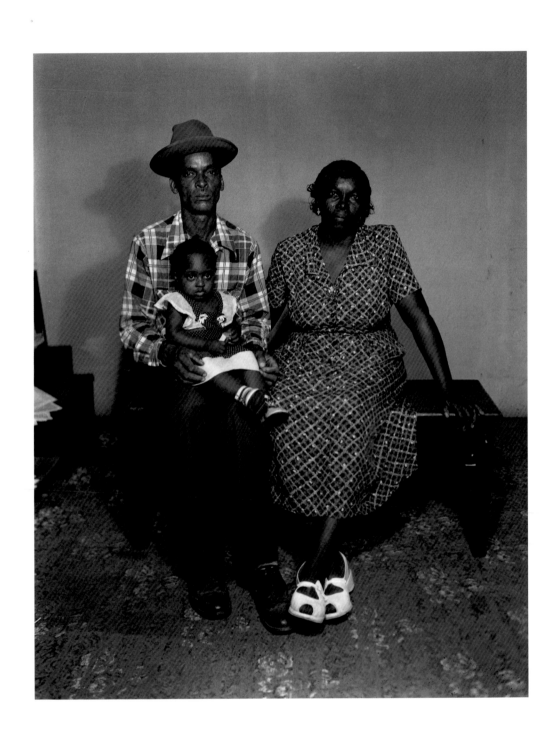

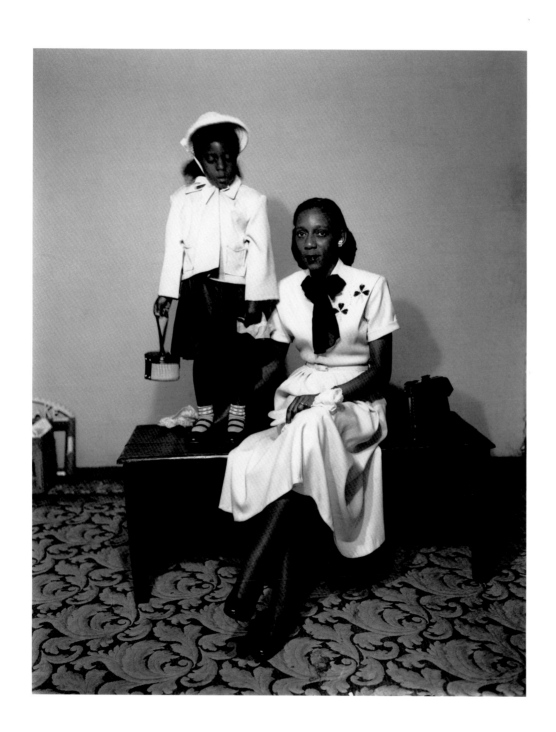

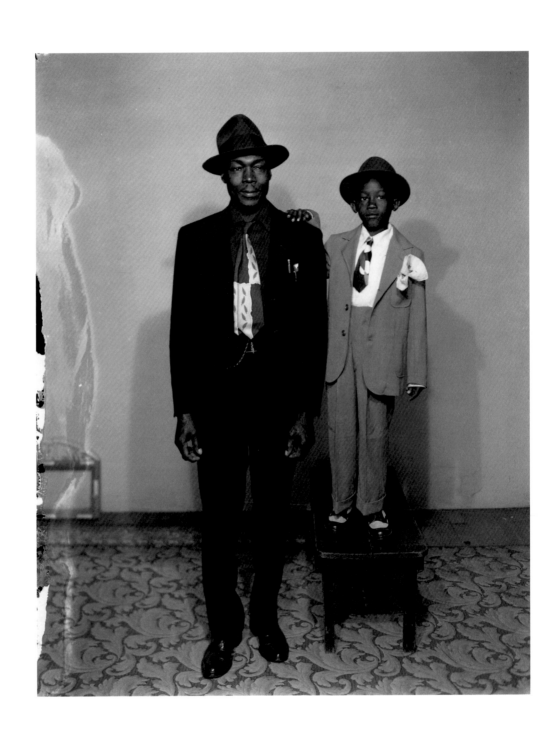

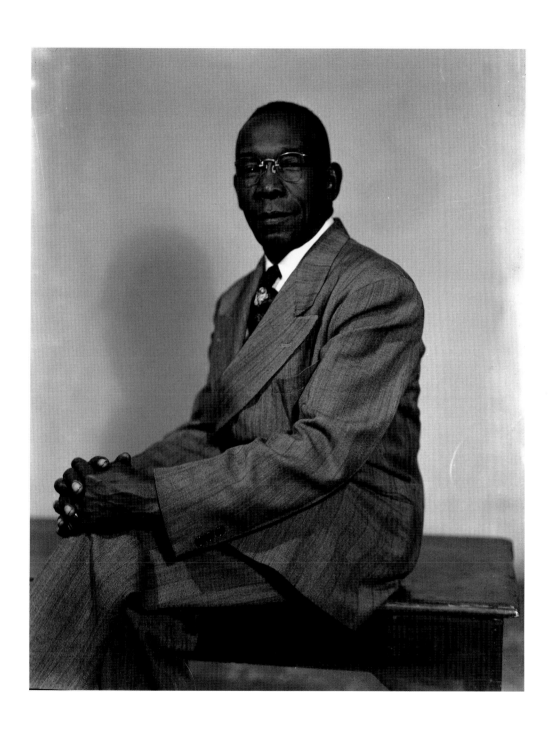

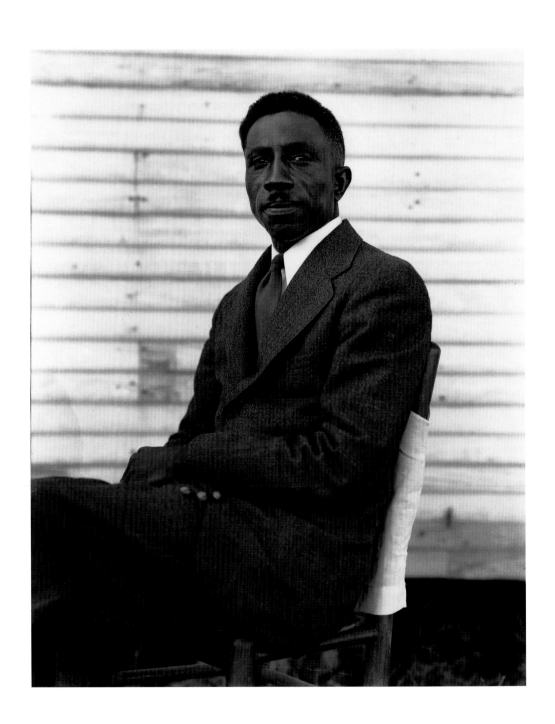

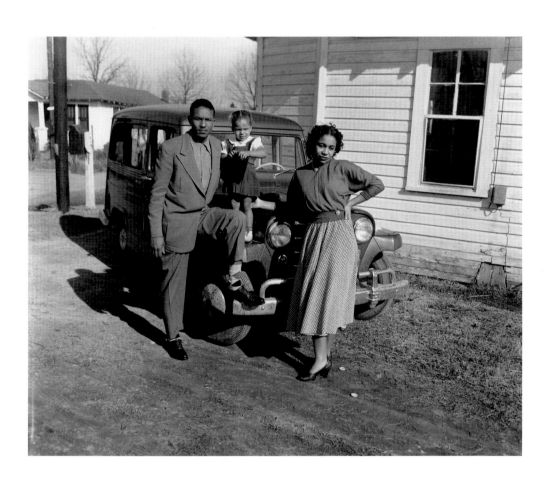

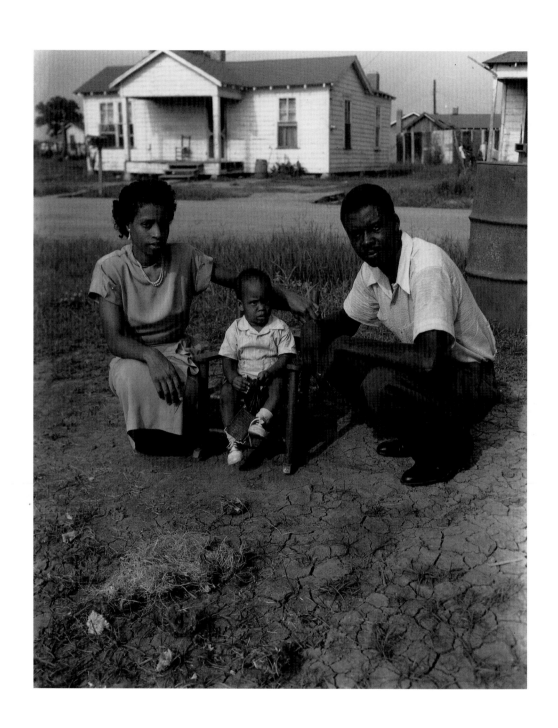

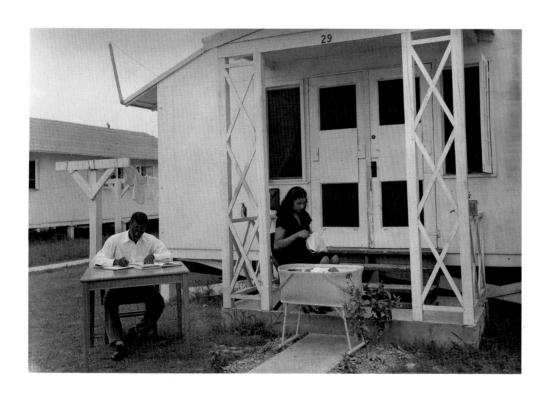

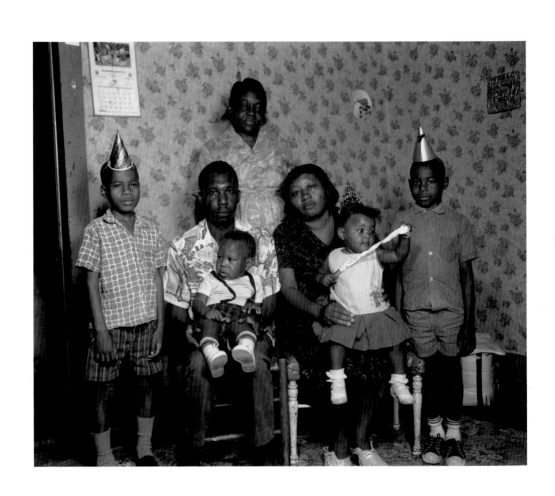

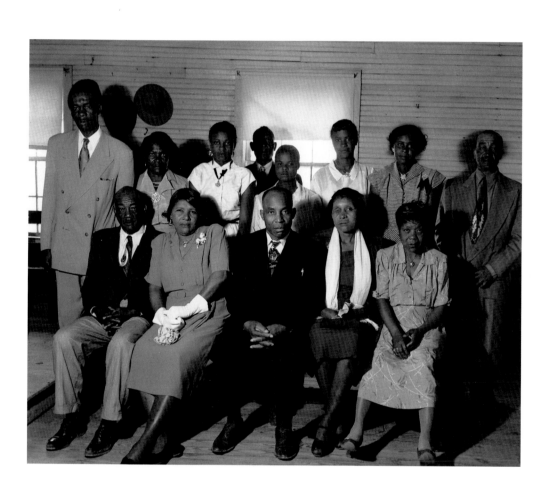

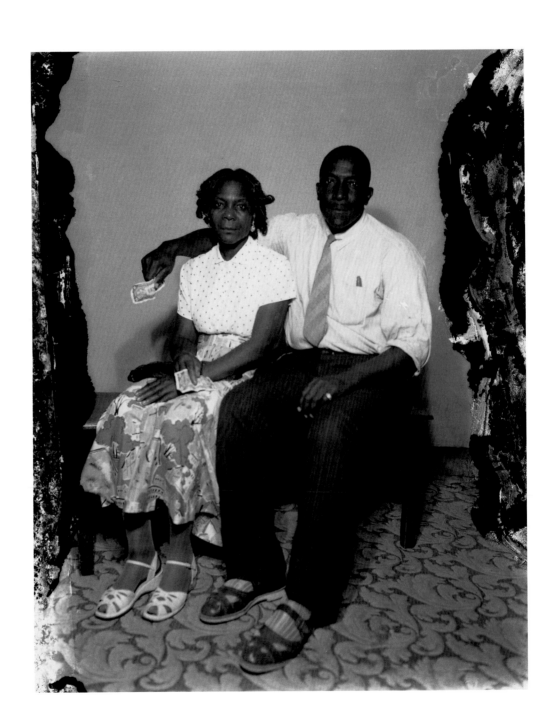

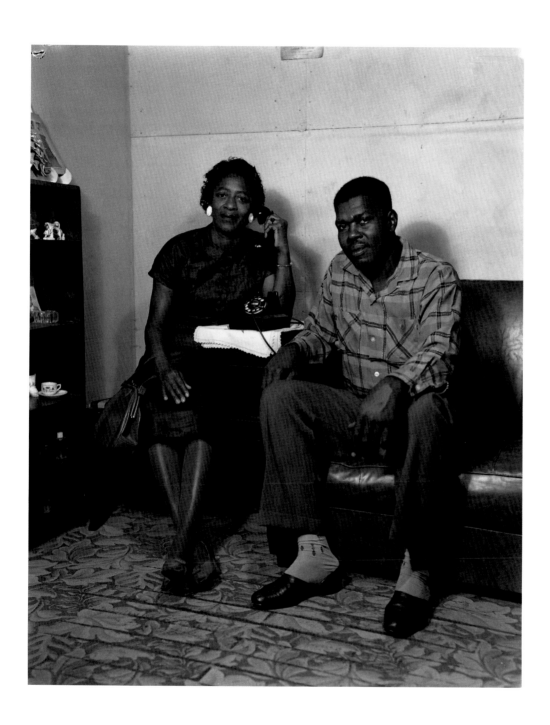

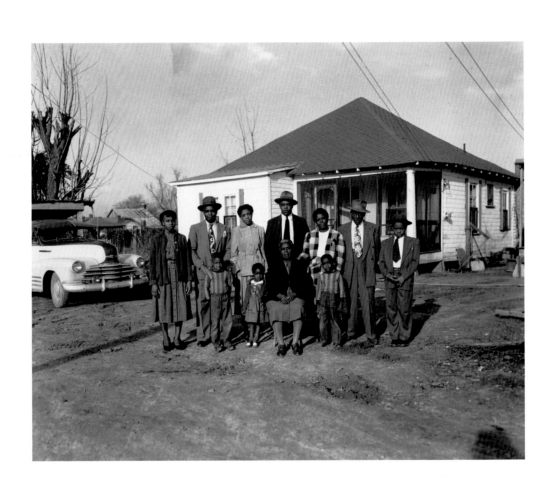

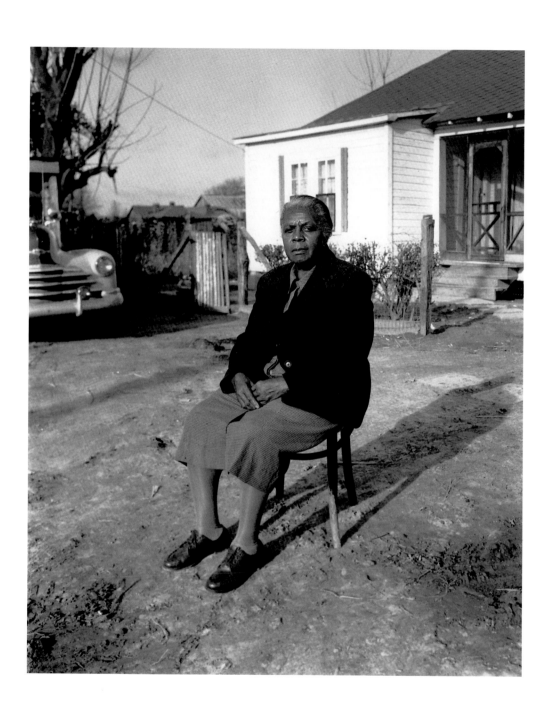

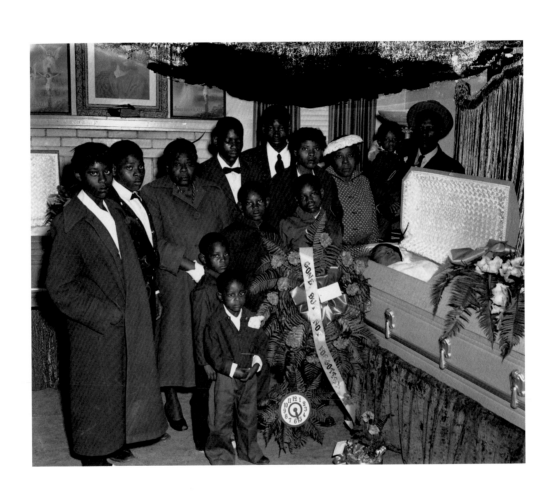

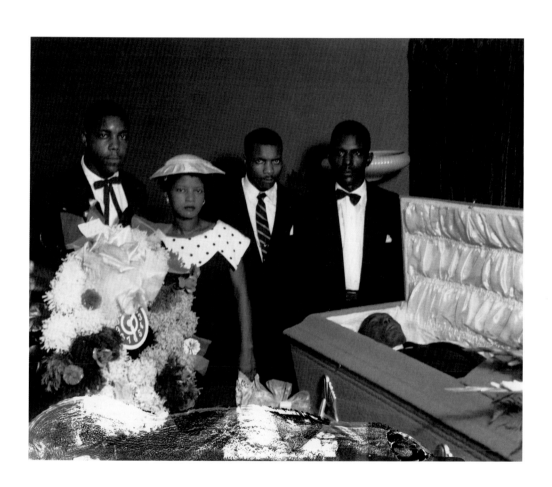

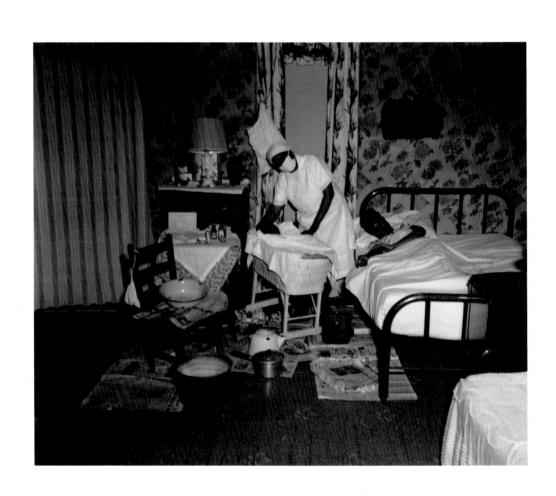

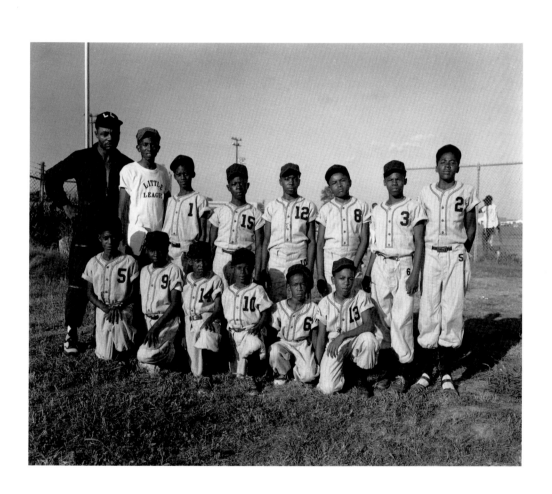

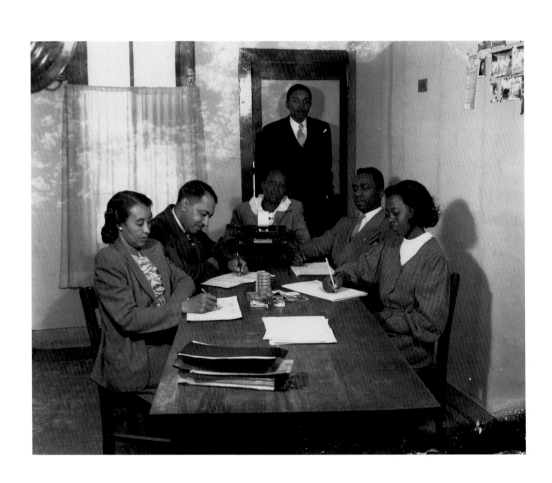

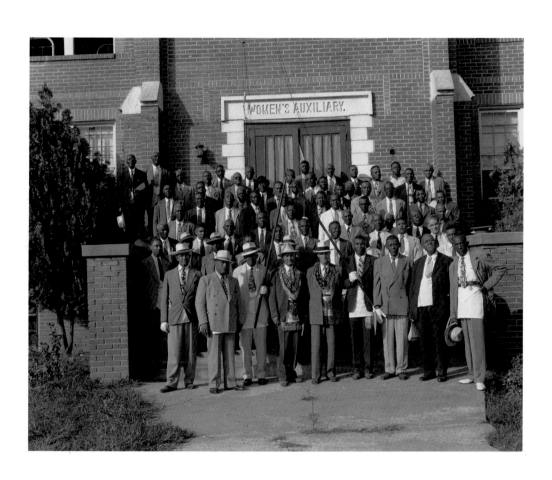

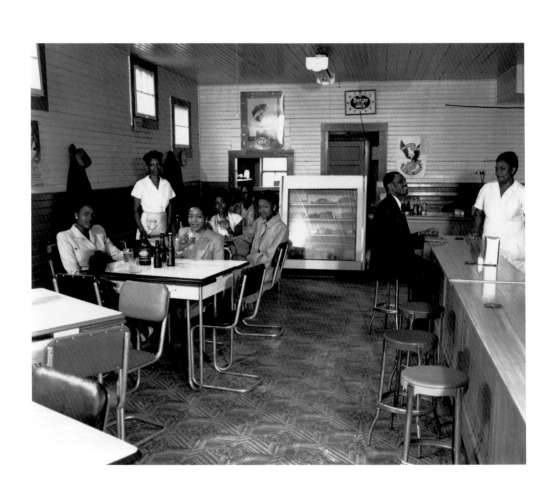

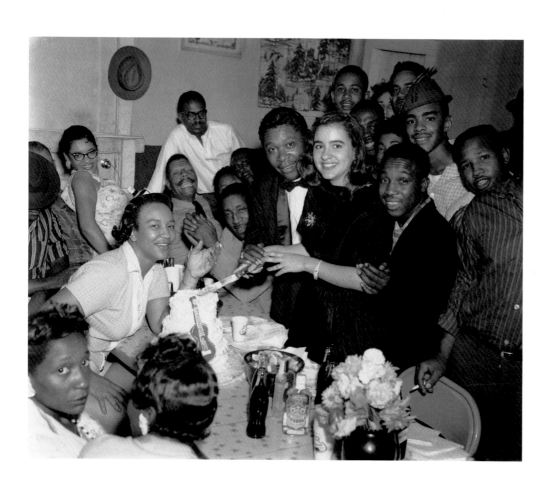

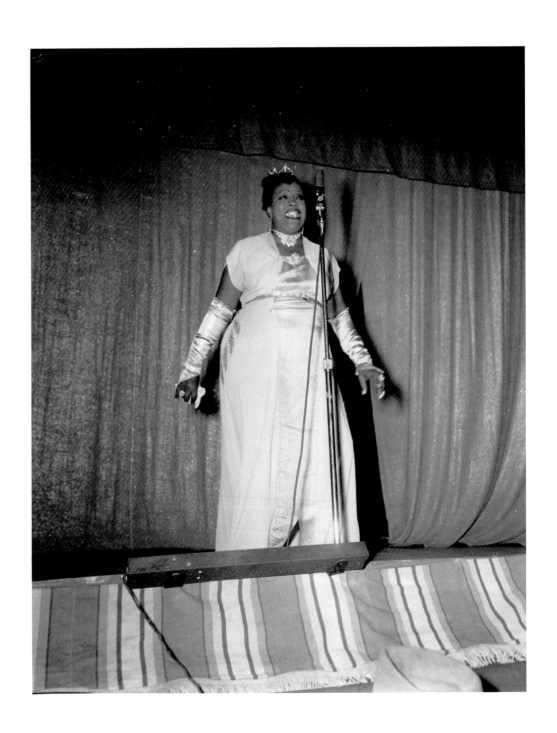

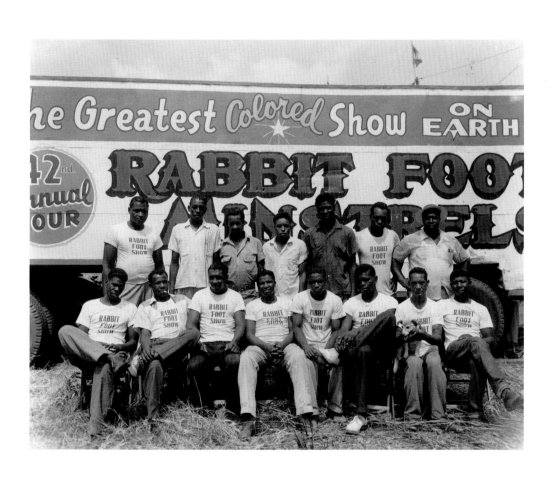

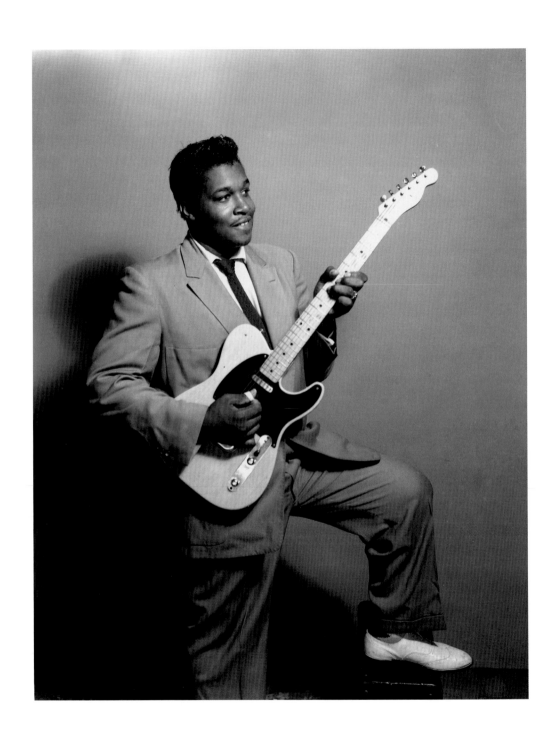

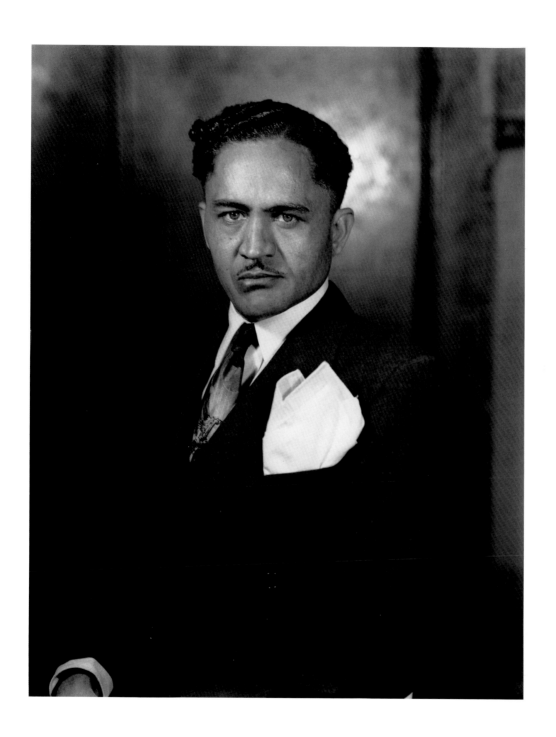

H. C. ANDERSON AND THE CIVIL RIGHTS STRUGGLE

Mary Panzer

HENRY CLAY ANDERSON MADE THE MOST IMPORTANT PHOTOGRAPHS OF HIS career in Belzoni, Mississippi, in the early hours of May 8, 1955, when a group of concerned citizens asked him to record events surrounding the death of their friend and neighbor, Reverend George W. Lee. A popular orator, advocate of voting rights, and leader of the local branch of the NAACP, Lee was also an obvious target for white activists determined to maintain legal segregation.

In 1954, the U.S. Supreme Court decision *Brown v. Board of Education of Topeka Kansas* called for the integration of all public schools. That summer, a group of white Mississippians met to organize the White Citizens' Council in response to the Supreme Court's action. Setting themselves apart from the notorious Ku Klux Klan, the council planned to bring an end to political activity by quieter means. They met privately with their targets, and calmly explained the penalties that could result from continued activism — contracts canceled, loans called in, credit stopped, jobs terminated. These threats often proved persuasive, but the council's strategy also intensified the atmosphere of fear on both sides of the color line, and when the council's methods failed, violence followed. The Citizens' Council quickly

Evidence of vandalism

spread throughout Mississippi and became a model for other networks in the South. With ironic justice that seems possible only in the Delta, Indianola was home to both the first meeting of the Citizens' Council and to Dr. Sissons, the committed activist who led Anderson through Belzoni, on what the photographer called "the most fearsome night in my life."

Thanks to efforts by George W. Lee and Gus Courts, by the spring of 1955 nearly one hundred black citizens had registered to vote in Belzoni. Founded in the early nineteenth century, and named for an Italian showman and explorer, Belzoni had long been known as a rough Delta town, with its own code of justice. Even the smallest success by Courts and Lee must have seemed astonishing and threatening to men like Ike Shelton, the local sheriff, and a reputed member of the council. No one could have been very surprised when the successful registration drive was followed by a night of vandalism that sent stones through windshields of eighteen cars on a single street in Belzoni's black community. The list of registered voters grew shorter, as did the roster of the NAACP. But political activity in the Delta continued, and rallies drew large crowds to hear eloquent speakers like Congressman Charles Diggs from Detroit, Dr. T.R.M. Howard from the all-black town of Mound

Bayou, and Reverend George Lee. Even after Lee found an unsigned threatening letter at his front door, he and Courts agreed to continue their efforts to register black voters.

Late on May 7, 1955, George Lee was shot down while driving home. Bullets first went through his tires. Then he was shot in the face at close range. His car smashed through the front porch of his neighbor, Katherine Blair. Lee died on his way to the hospital. Several witnesses saw a car drive away; some thought they saw a passenger who looked like Ike Shelton. The bad news spread quickly, and a group decided that they must have photographs to document this murder.

Several photographers turned them down, before they reached Henry Clay Anderson, who immediately agreed to come to Belzoni. Anderson followed Sissons and his friends

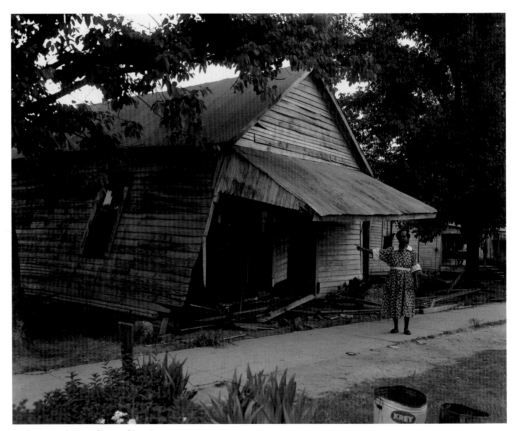

Katherine Blair in front of her house

from one place to another, "making pictures of anything [that] looked like where a shooting was or had been" — recording Mrs. Blair's broken porch, the car windshields shattered by stones, the damaged corpse of Rev. Lee, his bereft wife in bed. But when questioned the next day by the sheriff, eyewitnesses had grown forgetful, and the most important ones abruptly left town. Finally, Shelton declared Lee's shooting the consequence of a love triangle and identified the buckshot in Lee's face as tooth fillings that had shaken loose in the crash. Despite losing the lease on his grocery store, as well as credit with his supplier, Gus Courts continued to run his business. A few months later he, too, was shot. He survived and moved to Chicago, where he continued to speak out against violence in Mississippi.

Anderson's photographs documenting the tragedy in Belzoni appeared in *Jet* and in

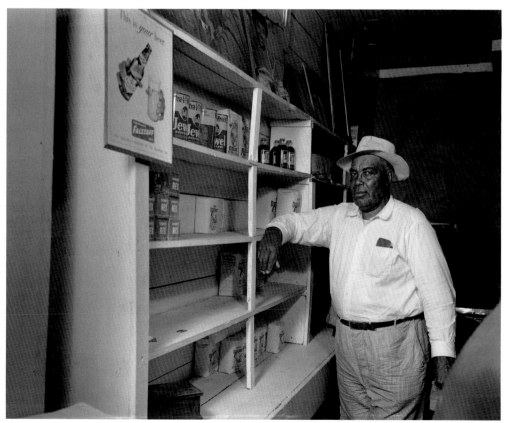

Gus Courts in his store

Ebony, as these magazines reported a long summer of accelerating violence in Mississippi. The story finally reached beyond the African American press on August 28, 1955, when Chicago teenager Emmett Till, visiting relatives in the Delta, was abducted, tortured, and killed for allegedly whistling at a white woman. National reporting of the Till case opened the white world's eyes to the injustice that prevailed in Mississippi and the south. Till's murderers were eventually identified, and even confessed to the crime in a national magazine, yet after a trial before an all-white jury, they were acquitted. And despite the horror aroused by photographs of the Till case published by *Jet*, violence against blacks did not diminish.

In *For Us, the Living*, her memoir of the early Civil Rights struggle, Myrlie Evers (widow of Medgar Evers, martyred in 1964 for his leadership of the Mississippi branch of the NAACP) explained that the death of George Lee had not caused any great alarm, because he "had been murdered for doing what everyone knew Negroes were murdered for doing" — insisting on his civil rights. Emmett Till's error, if any, was to be young and foolish. But his murder and the outcome of the subsequent trial proved "that even youth was no defense against the ultimate terror," that "whites could still murder Negroes with impunity," and "there would be no real change in Mississippi until the rest of the country . . . forced it."

Over the next decade, change came to Mississippi and the nation. The successful struggle for civil rights has now become a cherished national epic. Its fights and its leaders have become familiar in part through photographs by Dan Weiner, Danny Lyon, Flip Schulke, Charles Moore, and many others. With very few exceptions, these photographers came from the North, or from across the color line, and their work was shaped by the needs of the Civil Rights movement and the media. The photographs of H. C. Anderson come from a different tradition, which has been hidden from all but those who appear in these photographs.

H. C. Anderson was born in the tiny Delta town of Nitta Yuma on June 12, 1911, and aside from army service in World War II, and two-year's study in Baton Rouge, Louisiana, under the GI Bill, he spent his life in Mississippi, most of it in Washington County. Before the war, Anderson lived in the crossroads town of Hollandale, where he and his brothers studied with a gifted teacher, Professor Emory Peter Simmons. Born in 1858, E. P. Simmons attended Quaker-run schools after the Civil War, and began teaching in 1881. In the early 1920s, he raised funds for a new school for black students in Hollandale by tapping every possible source — black churches, white politicians, national foundations, and county, state,

and federal government grants. He almost certainly relied on good connections, for Simmons and Booker T. Washington married sisters, and early in the twentieth century, Simmons's son, Roscoe Conkling Simmons, became Washington's protégé, as well as a leading Chicago journalist. In 1941, when Simmons was eighty-three, Anderson and his brother organized a ceremony to name the Hollandale school in his honor. Formal speeches acknowledged his sixty-year career, yet his most important legacy, though never mentioned, was everywhere evident. The audience was filled with generations of his students, who knew themselves to be citizens of a democratic society, and who could and would secure justice with their votes.

Anderson often acknowledged that his debt to Professor Simmons began in 1920, when he started school: "At that time, you couldn't do much and it not be known, but he would teach us under cover, 'Boys, tell your parents, ask your parents, to buy a small piece of property [to meet the legal requirement for all Mississippi voters], register, and vote.' He said, 'If you vote, you'll have a voice in what's happening, but if you don't vote, you have no voice.' I talked to my parents, and my parents started voting, early. He said, 'You also could be elected. If you want to be the mayor of the town, if you get enough votes, you can be elected mayor of the town. Or even president of the United States.'"

History books commonly associate such optimism with immigrants who arrived in the United States at the turn of the twentieth century, but while Simmons and his generation entered American society with nearly as little experience as their European contemporaries, it is rare to hear this rhetoric from newly enfranchised African Americans — or, more accurately, it is rare to hear it outside the world that middle-class black families established as a refuge from the toxic culture of Jim Crow and legal segregation. This sheltered society can be glimpsed on the pages of high-toned magazines like *Ebony* and *Our World*, in the editorials of newspapers such as the *Pittsburgh Courier, Chicago Defender*, the *Baltimore Afro American,* and *Amsterdam News*, in the autobiographical essays of Ralph Ellison, and the novels of Zora Neale Hurston. However, by necessity, the black middle class deftly concealed its expression of confidence in the promise of American life, and as a result it remains difficult for an outsider to find today.

Anderson's work shows the ways black Greenville sheltered its proud local culture, holding fancy dress suppers in private homes, and raising private funds to supplement state support for Coleman High School and for vocational training, eventually hosting one of the nation's first Head Start programs. Sometimes these activities were actually con-

cealed by the documents themselves. After all, one assumes that family portraits and photographs of everyday events such as high school graduations, homecoming parades and dances, weddings, funerals, or fundraising fashion shows were made only for the people in the pictures and their friends. These are images no stranger would expect to see.

Anderson ran his studio on Nelson Street for over thirty years, and after he closed the business in 1978 he continued to work part time for another decade. Though it is impossible to know how much work Anderson discarded, he kept hundreds of old negatives, including much of his earliest work, and many images of the extended Anderson family. Seen together, these photographs depict a world that confounds conventional expectation. In part, they are surprising because they seem so ordinary. The files of any portrait studio

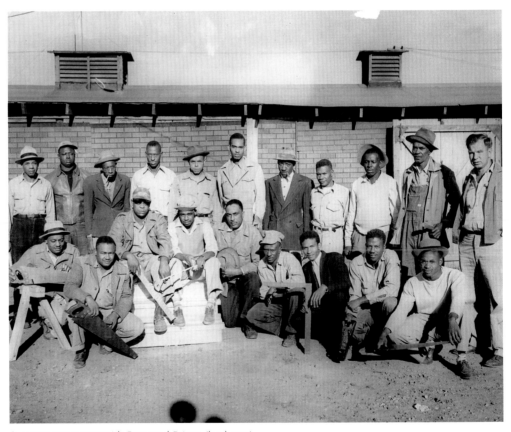

A construction crew with Reverend Prince (back row)

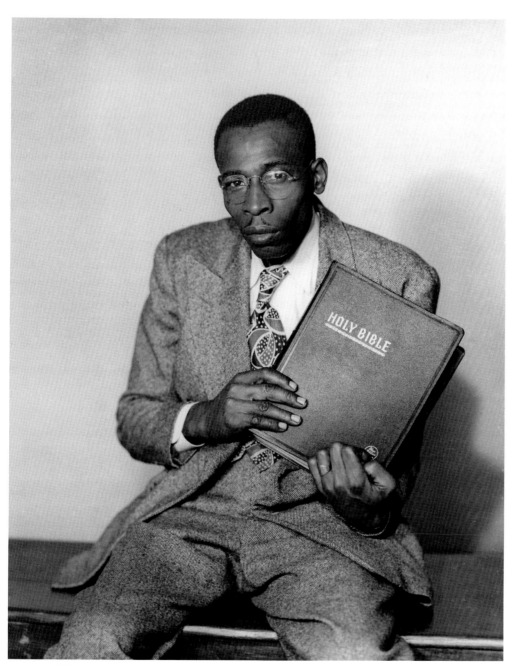

Reverend W. M. Prince

contain pictures of cute children, pretty young women, brides, young families, handsome men in tuxedos with glamorous women in long gowns, dignified elders standing on the steps of schools and churches. Like most community photographers, Anderson often photographed one sitter on many occasions. Several young women appear as high school girls, brides, and mothers.

Like all portrait subjects, Anderson's sitters were anxious to look their best, and dressed up for the occasion. For his part, Anderson arranged the pose, the lights, even added makeup and styled hair if necessary. But dress alone did not create the difference between the men and women who sat for Anderson's camera and the citizens who were photographed working for and with their white neighbors in Greenville. Anderson and his friends would easily recognize Reverend Prince, with his twisted back, standing in a big group picture of a construction crew. Yet one doubts that, on first glance, the crew's foreman would recognize Reverend Prince in this portrait by Anderson, sitting comfortably in his tweed suit, holding a Bible. Confident, assured, matter-of-fact, Anderson's sitters have no reason to doubt or question their ability; their limits are the ones that any human being must strive to overcome. But these are the faces of individuals as they appeared in the territory behind the color line. When they crossed the street into white Greenville, these faces vanished.

Through its decorous silence, black Greenville was able to nourish a large, safe environment in which several generations flourished. But when integration finally came, this community habit also produced an unintended effect — the rapid onset of historical amnesia. As a young generation dimmed memories of Jim Crow culture they also discarded recollection of the world Anderson captured on film. One could compare Anderson's Greenville to the water in a crystal glass — once the glass breaks, the contents also vanish.

Anderson's strong commitment to justice consistently led him to help others even when his actions placed him at risk. As a young man, he left an industrial job to become a teacher, though his monthly salary equaled about a week's wages at the factory. As a soldier in the segregated army, he insisted on fair treatment for those too timid or illiterate to know their rights. In the late 1950s he opposed local black leaders who preferred not to challenge the white establishment, and he worked with the Southern Christian Leadership Council (SCLC) to conduct secret classes to prepare prospective voters to pass the literacy test that stood in the way of registration. In the early 1960s he supported the Freedom Democratic Party, and ran as a Freedom Democrat when he was one of the first black candidates to vie for a seat on the Greenville City Council.

Anderson also understood that his political convictions influenced his work in the studio. He viewed his portraits as documents of a sitter's whole life. As he explained in a late interview, "A photographer understands that the picture will show what is in the person . . . and if you're not interested you will not draw out what you should draw out. You must realize that the picture will tell a story [and you] should try to make the best pictures, try to bring out more, try to show what really happened when the picture was made." Anderson's professional philosophy may account for his unusual ability to photograph women, best shown in the series he titled "Bathing Beauties." Anderson apparently made some of these images for local pageants, and made others for pleasure. What "really happened" when these pictures were made? He photographed young women in bathing suits in his studio, outdoors on the grass, at the pool, against a tree, walking down the road, and as always, his subjects appear relaxed, happy, and self-assured. All of them look beautiful. His portraits of children express the affection of a community — when he showed "what [was] in" these young people, he expressed their hope for the future.

H. C. Anderson had prepared well for his trip to Belzoni — through his studies with Professor Simmons, his work as a teacher, his career in the army, and his daily trade, which enabled him to record Greenville at its best. Today his photographs open the door to a long neglected chapter in the early history of the Civil Rights movement. Through his pictures we meet the generation who prepared the way for the activists of the late 1950s. They were the first men and women to register to vote, their children were the first to attend integrated schools and universities. This archive helps to show how Anderson's own vision made an essential contribution to this history by helping to form the people and places he photographed. Near the end of his life, Anderson shared this advice to all young photographers starting out, "[Tell him] to try to show not the picture only, but show the person who had the ambition. And if he's showing it, he shows himself."

SOURCES CONSULTED

Barry, John M. *Rising Tide: The Great Mississippi Flood of 1927 and How it Changed America*. New York: Simon & Schuster, 1997.

Branch, Taylor. *Parting the Waters: America in the King Years*. New York: Simon & Schuster, 1988.

Carter, Hodding, Jr. *Where Main Street Meets the River*. New York: Rinehart, 1953.

———"The South's Finest Negro School." *Ebony* 5 (December 1949): 13–18.

———"A Wave of Terror Threatens the South." *Look* Magazine 19 (March 22, 1955): 32–36.

———"The South and I," *Look* Magazine 19 (June 28, 1955): 74ff.

Chafe, William H., Raymond Gavins, Robert Korstad, eds. *Remembering Jim Crow: African Americans Tell About Life in the Segregated South*. New York: The New Press, 2001.

Cobb, James C. *The Most Southern Place on Earth: The Mississippi Delta and the Roots of Regional Identity*. New York: Oxford University Press, 1992.

Cohn, David L. *Where I was Born and Raised*. New York: Houghton Mifflin, 1948.

Curry, Constance. *Silver Rights*, with an introduction by Marian Wright Edelman. Chapel Hill, N.C.: Algonquin Books, 1995.

Daniel, Pete. *Lost Revolutions: The South in the 1950s*. Chapel Hill: University of North Carolina Press, 1999.

The Delta Democrat Times

Dittmer, John. *Local People: A History of the Mississippi Movement*. Champaign: University of Illinois Press, 1995.

Evers, Medgar. "Why I Live in Mississippi." *Ebony* 14 (November 1958): 65–70.

Evers, Myrlie. *For Us, the Living*. New York: Doubleday, 1967.

Gates, Henry Louis. *Colored People: A Memoir*. New York: Knopf, 1994.

Henry, Aaron, with Constance Curry. *Aaron Henry: The Fire Ever Burning*. Introduction by John Dittmer. Jackson: University Press of Mississippi, 2000.

Johnson, Thomas L., and Phillip C. Dunn. *A True Likeness: The Black South of Richard Samuel Roberts: 1920–1936*. Chapel Hill, N.C.: Algonquin Books, 1986.

Levine, Lawrence W. *The Unpredictable Past: Explorations in American Cultural History*. New York: Oxford University Press, 1993.

Litwak, Leon F. *Trouble in Mind: Black Southerners in the Age of Jim Crow*. New York: Knopf, 1998.

"M is For Murder and Mississippi." NAACP Papers, Washington, D.C.

McLemore, Leslie Burl. *The Mississippi Freedom Democratic Party: A Case Study of Grass Roots Politics*. Ph.D. Dissertation, University of Massachusetts, 1971.

"Mississippi Gunmen Take the Life of Militant Negro Minister," *Jet* (May 26, 1955): 8–11.

Moody, Anne. *Coming of Age in Mississippi*. New York: Dell, 1968.

Morris, Aldon D. *The Origins of the Civil Rights Movement: Black Communities Organizing for Change*. New York: Free Press, 1984.

NAACP Papers, Library of Congress, Washington, D.C.

Naipaul, V. S. *A Turn in the South*. New York: Knopf, 1989.

"The New Fighting South: Militant Negroes Refuse to Leave Dixie or Be Silenced." *Ebony* (August 1955): 69–74.

Payne, Charles M. *I've Got the Light of Freedom: The Organizing Tradition and the Mississippi Freedom Struggle.* Berkeley: University of California Press, 1995.

Rowan, Carl, *South of Freedom.* New York: Knopf, 1952.

"Twilight of Two Eras [on Roscoe Conkling Simmons]." *Ebony* 6 (August 1951): 102–103.

U.S. Commission on Civil Rights. *Voting in Mississippi: A Report of the U.S. Commission on Civil Rights.* Washington, D.C.: Government Printing Office, 1965.

———. *School Desegregation in Greenville, Mississippi.* Washington, D.C.: Government Printing Office, 1977.

Walton, Anthony. *Mississippi: An American Journey.* New York: Knopf, 1995.

Washington County Library System. Oral History Project. 1977.

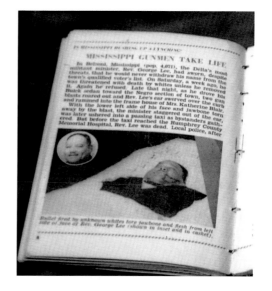

Jet, May 26, 1955

"A FEARSOME NIGHT"

H. C. Anderson

IT WAS A FEARSOME NIGHT FOR ME, ONE OF THE MOST FEARSOME NIGHTS in my life, the night I made pictures of Reverend Lee's funeral.

It was quite a night that I went down to Belzoni. Dr. Sissons and a small group from Indianola were upset to the extent they were trying to get pictures, trying to do something about it. They tried to get photographers from Jackson, a number of places, but all the [other] photographers refused to accept the job. Dr. S. M. Sissons recommended me. Not knowing, I accepted the job. They picked me up I guess about 10 or 11 o'clock the night that he got killed. When we got to Belzoni, north of Belzoni, across the highway, is a sign, saying Belzoni, and a few words about the city. I went through the gate, made pictures of the gate. I still was at a loss because I didn't know what I was getting into. I knew that we were going into Belzoni but I didn't [know] we were going into this. I didn't know what kind of pictures I would make when I got there.

Getting there and finding out what happened altogether, it was just frightening. They killed him on the side of his house. There was a group of people on the street, but not a big group. I was taking orders from Dr. Sissons and a small group from Indianola. We went

Belzoni, heart of the Delta

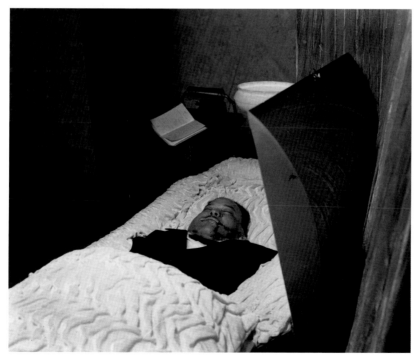

Reverend Lee in his casket

from one area to another, especially in the area where the car hit, making pictures of anything that looked like where a shooting was or had been. . . . It was just fearsome. It was a scary night because they said that it was so much danger out there with the camera flashing, the most fearsome night in my life. . . . But anyway, I went through making pictures. . . .

I was really afraid. I was shaking. I was shaking and I was thinking it would be over soon. A minister was leading us to places they wanted pictures. . . . The minister was shaking, just shaking with fear the whole time. I [was] just about as bad. The first place we went was the home of Reverend Lee, where they shot him as he was returning home. We made a picture of Mrs. Lee that night, ill, she was in bed. And we went to the funeral home, made pictures of Reverend Lee in the casket. We made pictures of a number of cars that had been shot through the windshield, shot into the car. We never did get a picture of [the] car that Reverend Lee got killed [in].

About a week later, we made pictures of the funeral of Reverend Lee at a big church. It was held outside the church. Quite a crowd was there. Reverend W. M. Walton was the minister who presided over the funeral.

After it was all over, I was able to make most of the pictures that magazines carried. I feel very good to have been recognized. [At that time,] there was a word that you were a good photographer when you could sell to *Time* and *Life* magazines. And through Mr. Hodding Carter, editor of the Greenville paper, I was able to sell the story of Reverend Lee who got killed at Belzoni. Really Mr. Carter did a lot to help me. He asked me to loan my negatives to him. That's the way my pictures got to the national magazines. I represented the *Democrat Times*, although I represented black papers also, I represented *Democrat Times* for Mr. Carter. I was able to sell both *Time* and *Life* magazine pictures, and we sold to the black magazine, *Ebony*. Thirteen out of fourteen pictures that *Ebony* used were pictures that I made. There were so many photographers that made pictures of the funeral and the things surrounding his death, I felt very good to be recognized. It was encouraging to me to know that I was able to get the most desired pictures. Because of my being inside a little . . . I was able to make pictures before the other photographers came in. I knew these were being published in *Life* and *Time* and *Ebony* because they were the most outstanding pictures. [Later] I was hired by the NAACP to make pictures.

I don't think nobody was ever brought to trial for Reverend Lee's murder. If there was, I didn't have knowledge of it.

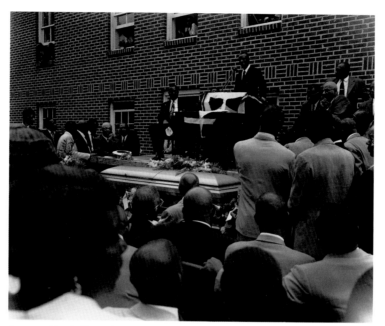

Reverend Lee's funeral

Mourners, including Mrs. Lee (center, looking down)

APPENDIXES

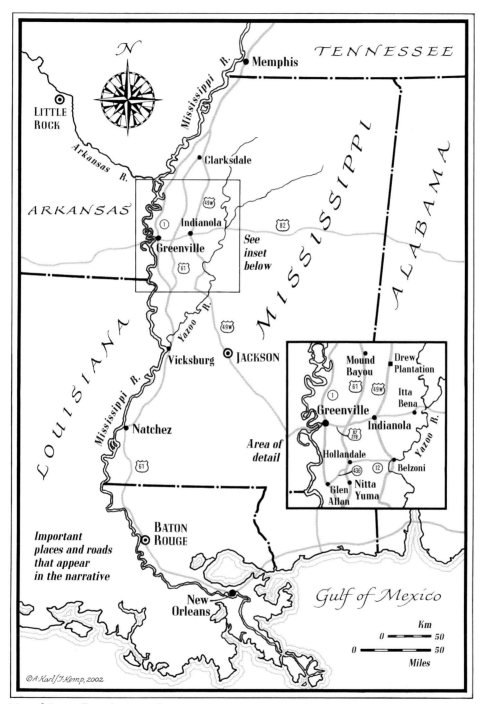

Map of Greenville and surrounding area

TIMELINE OF ANDERSON'S LIFE AND THE CIVIL RIGHTS MOVEMENT

1858 Emory Peter Simmons born in slavery

1861 Civil War begins, ends in 1865

1896 Supreme Court Case, *Plessy v. Ferguson* condones "separate but equal" accommodations, making segregation legal throughout the United States

1908 William Howard Taft elected President; serves one term

1909 Founding of the National Association for the Advancement of Colored People (NAACP)

1911 Henry Clay Anderson born June 11, Nitta Yuma, Mississippi

1912 Woodrow Wilson elected President; serves two terms

1917 U.S. enters World War I

1920 Warren Harding elected President

 Anderson begins school in Hollingdale, studies with Professor E. P. Simmons

1923 Bessie Smith makes her first recording for Columbia Records

1923 Harding dies in office. Calvin Coolidge becomes President

1924 Calvin Coolidge re-elected President

1925 A. Phillip Randolph establishes Brotherhood of Sleeping Car Porters, the first successful black labor union

1927 Great Mississippi Flood nearly destroys Greenville

1928 Herbert Hoover elected President; serves one term

1930 Anderson obtains teaching license, Belzoni, Mississippi

1931 Anderson registers to vote in Hollandale, Mississippi

Eight young black men sentenced to death and one to life in prison after being falsely accused of rape in Scottsboro, Alabama, beginning a six year series of trials that reach the Supreme Court and make international headlines

1932 Franklin Delano Roosevelt elected President; serves four terms

1936 Jesse Owens wins four gold medals at the Berlin Olympics

1937 Anderson begins teaching high school with Professor E. P. Simmons, Hollandale

1938 Joe Louis defeats Max Schmeling to become boxing champion of the world

1939 Marian Anderson, banned from Constitution Hall in Washington, D.C., performs before 75,000 people at the Lincoln Memorial

1941 U.S. enters World War II

1942 Anderson interrupts his profession as high school teacher to enlist in U.S. Army

1943 Anderson trains in Camp Shelby

1945 Anderson discharged, U.S. Army Hospital, Long Island, and returns to Mississippi, studies photography at Southern University in Baton Rouge, Louisiana, on the GI Bill

Roosevelt dies in office. Harry Truman becomes President

1946 Anderson marries Sadie Lee, August 26

With his brother, Anderson organizes ceremony in Hollandale honoring Professor Simmons, naming Simmons High School in his honor

1947 Jackie Robinson joins Brooklyn Dodgers

1948 Anderson opens Anderson Photo Service on Nelson Street in Greenville, Mississippi

Harry Truman re-elected President

1949 Anderson moves studio to 1002 Nelson Street

Anderson takes photographs for Coleman High School homecoming and begins taking yearbook photographs for Coleman High School and Mississippi Vocational College

1952 Dwight Eisenhower elected President; serves two terms

1954 U.S. Supreme Court issues decision on *Brown v. Board of Education*, overturning *Plessy v. Ferguson*

1955 At the request of local black leaders, Anderson photographs events surrounding assassination of Rev. George W. Lee in Belzoni

With the help of Hodding Carter, editor of the *Delta Democrat Times*, Anderson's photographs appear in *Jet* and *Ebony*

Anderson continues to photograph for the NAACP

Emmett Till, fourteen-years-old, lynched in Money, Mississippi, for whistling at a white woman. National press coverage led by *Jet* Magazine

Bus boycott begins in Montgomery, Alabama, when Rosa Parks is arrested for refusing to move to the back of a city bus

1957 Martin Luther King, Jr. leads founding of the Southern Christian Leadership Conference (SCLC)

Federal troops sent to Little Rock, Arkansas, to protect African American students entering Central High School

1960 Ella Baker helps establish Student Non-Violent Coordinating Committee (SNCC)

Black students stage first "sit-in" to protest segregated lunch counter in Greensboro, North Carolina

John F. Kennedy elected President

1962 James Meredith becomes first African American student to attend University of Mississippi, protected by federal troops

1963 Anderson works with the SCLC, teaches adult literacy classes. 100 students pass state literacy test, register to vote

Massive march for civil rights brings thousands to Washington, D.C., Martin Luther King, Jr. delivers "I have a dream" speech

Medgar Evers, Mississippi field secretary for NAACP, assassinated outside his home in Jackson

President John F. Kennedy assassinated. Lyndon B. Johnson becomes President

1964 Anderson photographs inauguration of Freedom Democratic Party with Ella Baker, Fanny Lou Hamer, Aaron Henry

Martin Luther King, Jr. wins Nobel Prize for Peace

Freedom Summer brings Northern students to Mississippi to register voters. Project workers Andrew Goodman, James Cheney, and Michael Schwerner are killed in Philadelphia, Mississippi

Civil Rights Act of 1964 ends segregation in public schools and all public places

Fanny Lou Hamer and Freedom Democrats protest all white Mississippi delegation to the

Democratic National Convention, Atlantic City

Lyndon Johnson re-elected President

1965 Anderson runs for City Council as a Freedom Democrat

Anderson photographs Thelma Barnes and Greenville Head State program

Anderson visits Washington, D.C., attends Congress, present at passage of Civil Rights Act of 1965

Voting Rights Act of 1965 protects voting rights for all citizens

1966 Anderson's adopted daughter, Lois Jean McDowell Anderson, and seven other black students graduate in first integrated class of Greenville High School

1967 Thurgood Marshall becomes first black Justice of the United States Supreme Court

1968 Martin Luther King, Jr. assassinated, Memphis, Tennessee

Robert F. Kennedy assassinated, Los Angeles, California

Richard Nixon elected President

1971 Anderson runs for Justice of the Peace

1974 Anderson teaches photography at Mississippi Valley State University

Richard Nixon resigns. Gerald Ford becomes President

1976 Anderson receives citation for Distinguished Service from Cliff Finch, Governor of Mississippi, as "a leader of fraternal, civic, and community endeavors"

Barbara Jordan delivers keynote address at the Democratic National Convention

Jimmy Carter elected President; serves one term

1977 Anderson runs for City Council, Ward 4

1978 Sadie Lee Anderson dies

1980 Ronald Reagan elected President; serves two terms

1986 Anderson closes studio, works part time from home, 340 N. Edison Street

1988 George Bush elected President; serves one term

1991 Clarence Thomas named a Justice on the United States Supreme Court

1992 Bill Clinton elected President; serves two terms

1996 Death of Anderson's adopted daughter, Lois, in Indianapolis, Indiana

1998 Anderson meets Shawn Wilson and is interviewed on film

Anderson dies in Greenville, Mississippi

THE ANDERSON PHOTO SERVICE PROJECT

The images in this book come from the archive of H. C. Anderson, now owned jointly by Charles Schwartz, a dealer and collector of photography, and Shawn Wilson, a filmmaker who grew up in Greenville, Mississippi. As Wilson describes in "Meeting Mr. Anderson," his discovery of Anderson's work began with the quest for a portrait Anderson made of his mother. Mr. Anderson eventually bequeathed his entire collection to Wilson in the hope the young filmmaker would bring his photographs to the attention of the public.

After Mr. Anderson died in 1998, Wilson and Schwartz traveled to Greenville to inspect the collection. At one point they discovered more than 1,500 negatives in corroded cardboard boxes under the kitchen sink in Anderson's home. The negatives were in deplorable condition, damaged by water and compacted together with mold. Wilson and Schwartz had the negatives separated, washed, and archived in acid-free envelopes. They also inventoried Anderson's vintage prints, placing them in acid-free sleeves.

As they collected more and more images they began to wonder about the subjects in Anderson's photographs. Many negatives came with names attached. They researched oral histories in Mississippi libraries, trying to match the stories to the names and faces in the photographs.

It seemed only natural that Anderson's photographs should be compiled in a book. Wilson and Schwartz joined forces with New York publisher PublicAffairs, which immediately recognized the his-

Charles Schwartz and Shawn Wilson in
Greenville, September 2000

torical value of the collection as a testament to the pride and dignity of middle-class Southern blacks at the dawn of the civil rights movement. The result is this book.

The photographs in this book are but a small sampling of the Anderson archive. There is an enormous amount still to be discovered from the more than 5,000 images and objects Anderson left behind. It is astonishing and sobering to see how easily the archive could have been lost if Wilson and Schwartz had not worked together to revive Anderson's collection. The successful partnership of an ambitious young black filmmaker, a liberal New York photography dealer, and a publisher with a taste for history reflects all the unconventional optimism found in Anderson's own pictures. And as this book promises, many more stories still lie undiscovered in the thousands of images by H. C. Anderson that have not yet been published or printed, and in the archives of others like him that remain for others to find, and bring to life.

We know that the images in this book were made by H. C. Anderson between 1947 and the early 1980s. Anderson identified many sitters and places, but provided no dates or formal titles. In lieu of captions, the list below identifies each image by page number, and gives Anderson's text or a descriptive title, along with the catalogue number assigned by the Anderson Photo Service Project.

LIST OF ILLUSTRATIONS

Meeting Mr. Anderson by Shawn Wilson

Pictures Made Any Time, Any Place, Any Size by H. C. Anderson

As If We Were There . . . Remembering Greenville by Clifton L. Taulbert

The Photographs of H. C. Anderson

H. C. Anderson and the Civil Rights Struggle by Mary Panzer

"A Fearsome Night" by H. C. Anderson

STATEMENT

ANDERSON PHOTO SERVICE
PICTURES MADE ANYTIME, ANY PLACE, ANY SIZE
PHONE 7769
340 NORTH EDISON STREET
GREENVILLE, MISS.

DATE_____195___

ACKNOWLEDGMENTS

From Shawn Wilson

I wish to thank Neale Albert, Jeanette Aycock, Reverend Calvin, Kate Darnton, Seth Goldman, Jodie Jacobson, Wilder W. Knight III, Matt Lass, Mary Panzer, Nancy Drosd, Jeff Forney, Brenda Pope, Lucas Spalding, Charles Schwartz, John Stevenson, Cliff Taulbert, Sharon Wilson, and Mary Yearwood. I wish to give a very special thanks to my friends and family in Mississippi, New York, and Wisconsin. I wish to thank David Wilson (my soul brother and partner in crime) for taking my words and stories and helping me to recreate them on the page. And finally, my most heartfelt thanks must be reserved for my life partner, Martin Eiden, the most supportive partner imaginable, who was not only kind and understanding throughout, but who has also spent a considerable amount of time keeping my eyes on the prize.

From Clifton Taulbert

Without the generosity of my great-great grandfather, Rev. Joe Young, I never would have experienced Greenville. Without him, I never would have seen the homes of the black doctors, lawyers, and the scores of educators who were part of its quiet middle class. From his

car windows, I saw their world. I thank my wife, Barbara, for listening to me as I traveled back to those places. I thank Mrs. Millicent Jackson, my high school science teacher, who validated the memories I held. Of course, I thank my cousins, Matthew and Vivian Page, who assured me that the people I remembered did exist. Special thanks to my brother-in-laws, Douglas Smith and Charles Perry, who lived their lives in and near Greenville. Douglas knew Reverend H. C. Anderson and has the photos to prove it. Because of these people and their recollections, I was able to capture in writing the world I saw from the windows of a 1949 Buick.

From Mary Panzer

Great thanks to Charles Schwartz and Shawn Wilson for inviting me to join them in learning about H. C. Anderson and his photographs, and to Kate Darnton, Peter Osnos, and the team at PublicAffairs, who believed strongly in the project from the very start. Randall Burkett, Pete Daniel, Jacqueline Goldsby, Janet Greene, Joan Karasik, and Grace Palladino generously gave essential information and support. I owe most to George Roeper, headmaster of a school that was always integrated, and Lola Scott, my first best friend.

From Charles Schwartz

I wish to acknowledge Neale Albert, Mort Goldfein, Jodie Jacobson, Mary Panzer, Anna May Walker, Shawn Wilson, and Mary Yearwood. I thank publisher Peter Osnos, editor Kate Darnton, and the rest of the PublicAffairs staff for seeing the book behind the photos. And I thank my wife, Nancy Drosd, for her love and support in this project and in life.

INDEX

For Ambassador Edward J. Perkins, 1928–2020

"My craft is diplomacy, and it is my soul that allows me to believe in the work that I am doing and to attempt to do that work with knowledge, wisdom, mindfulness, and compassion."
(Perkins 2006, 100)

Ambassador Perkins embodied the meaning of public service, international engagement, excellence, and learning. He was a champion of diversity and equity throughout his life and career. His journey demonstrates what is possible, even against the odds. He is an inspiration to us all.